THE PAINTER'S
STUDIO
HANDBOOK

TOOLS AND TECHNIQUES

Simon Fletcher

A & C BLACK • LONDON

For Mark Fletcher, for his advice, help and encouragement in producing this book.

First published in Great Britain 2012 by
A&C Black Publishers
an imprint of Bloomsbury Publishing Plc
50 Bedford Square
London WC1B 3DP
www.acblack.com

Copyright © Simon Fletcher 2012

ISBN 978-1-4081-4537-1

A CIP catalogue record for this book is available from the British Library.

Simon Fletcher has asserted his rights under the Copyright, Design and Patents Act, 1988, to be identified as the author of this work.

This book is produced using paper that is made from wood grown in managed, sustainable forests. It is natural, renewable and recyclable. The logging and manufacturing processes conform to the environmental regulations of the country of origin.

Cover design: Sutchinda Thompson
Page design and layout: Susan McIntyre
Publisher: Susan James
Project manager: Davida Saunders
Copy editor: Fiona Corbridge
Proofreader: Jo Herbert

Typeset in 10 on 13pt Minion

Printed and bound in China

CONTENTS

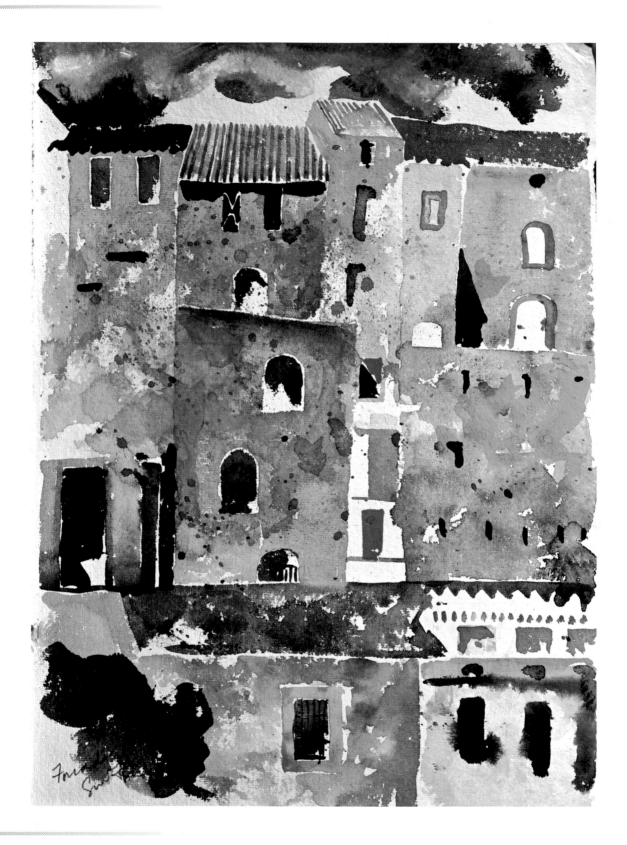

6

ACKNOWLEDGEMENTS

I would like to thank Michael Bailie, Bob Miller, Adrian Gibbs and the technical staff at the Bridgeman Art Library for their help and advice about photography archives, Michael Harding for his kindness in sending me some of his splendid products to test, Jackson's Art Supplies for their very good products, many of which I would highly recommend, Dick Blick (USA) for sending me a good selection of their products, Gamblin Artists Colors Co. (USA) for their oil paints and mediums, Golden Artist Colors, Inc. (USA), Spectrum Paints (UK) for a sample of their studio colours, Winsor & Newton for their watercolours, Maimeri (Italy), Kremer Pigments Inc. for their colour boxes, Blockx for their large watercolour box and selection of colours, and Daler Rowney for some generous samples.

I am also grateful to the Barraclough family for allowing me to use the Atelier du Haut Languedoc for some of the shots in this book, all my students and friends who have encouraged me to produce a book that will help them with their painting, my editor at Bloomsbury, Davida Saunders, who was patient and kind in helping to produce the book, and Julie who helped me through every stage of it.

FACING PAGE: *Facades III*, watercolour on Indian handmade paper, 38 x 27cm (15 x 10½ in.).

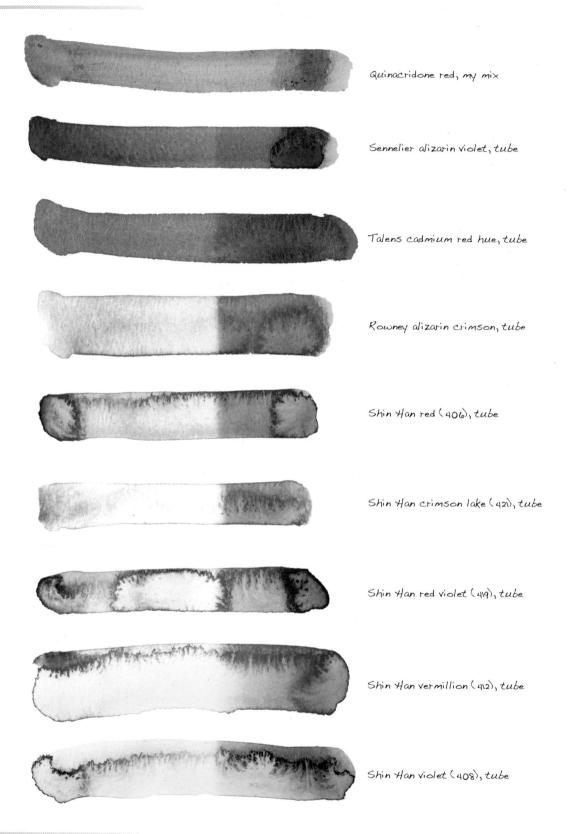

Quinacridone red, *my mix*

Sennelier alizarin violet, *tube*

Talens cadmium red hue, *tube*

Rowney alizarin crimson, *tube*

Shin Han red (406), *tube*

Shin Han crimson lake (421), *tube*

Shin Han red violet (419), *tube*

Shin Han vermillion (412), *tube*

Shin Han violet (408), *tube*

INTRODUCTION

For many years I have painted in a variety of media (oil, watercolour, pastel and acrylic), made prints and taught printmaking, used all sorts of photography from traditional formats to digital RAW files, and learned to use a computer in order to publish eight books about my work. In addition to this, both as a means of making money but also because it is fun, I have regularly given seminars on painting in watercolour and using pastels. Students nearly always ask me for technical information and it is surprising how little most people know about different materials and how to use them.

This book covers all the essentials for producing successful paintings, from choosing your first colours, supports and brushes to designing and equipping your own studio. It will enable painters who have limited time or money to get started without needing lots of equipment, using materials and techniques that have been tried and tested over generations. I also hope to inspire a new curiosity amongst artists who have never really thought about their materials very deeply. This is a fascinating subject and I hope it will become a lifelong interest for you as it has for me.

OPPOSITE: For a description of how to test your colours see pp.47–8.

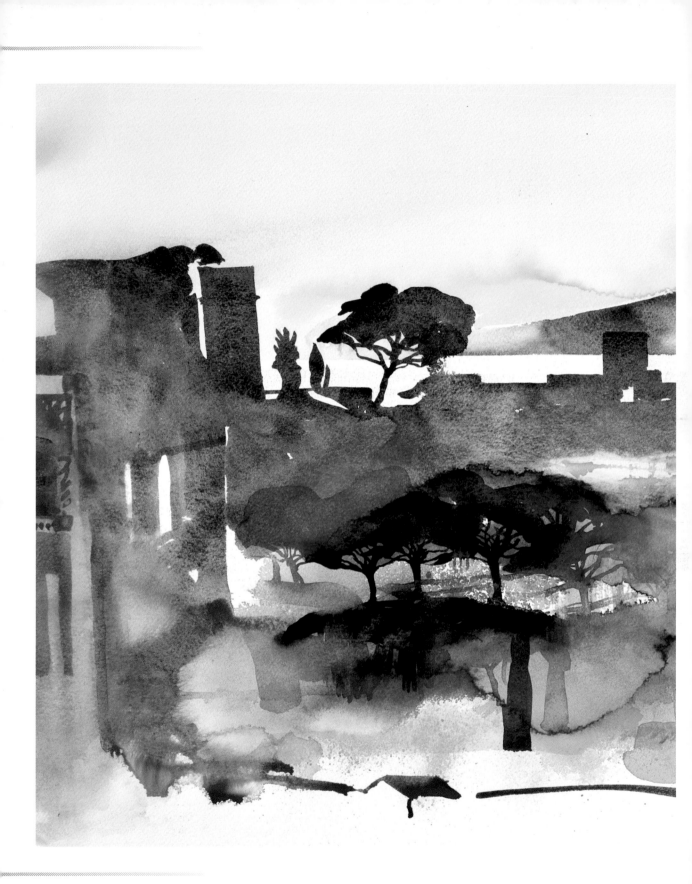

1

THE IMPORTANCE OF TECHNIQUE

The history of painting (and indeed of most of the arts until the end of the 19th century) is one of technique. When Jan van Eyck painted his portrait of the Arnolfinis in the 15th century, he used oil paints on a prepared cradled panel (see p.87), which is still one of the most enduring techniques known in painting; if he had not done this, the work would not have survived in the good condition we are able to see it in today. By contrast, in the 19th century, thousands of watercolour painters used the charming soft colours of lake pigments (pigments extracted from dye), often taken from plant roots.

Once exposed to fairly strong light, lake pigments fade almost completely, thus giving us the typical look of a painting in Granny's watercolour collection: a little grey blob in a gold frame. Thank goodness the cave painters used earth pigments, often bound with animal fats, to create their magnificent depictions of animals, and the Chinese used permanent inks on beautiful silks and papers for their scrolls.

It should be noted, however, that all artworks, no matter how permanent the materials, suffer from long exposure to strong light.

CONTEMPORARY PRACTICE

There has been a recent trend in the visual arts to play down the techniques used to create artworks, and to attach little importance to the permanence of the materials used. I know some painters who use old, cellulose-based wallpapers in collages, others who make drawings on cheap newsprint, and many who store their information on CD-ROM[1]; also some sculptors who use

LEFT: *Scala* (detail), watercolour on Hahnemuhle 300 gsm paper, 56 x 76 cm (22 x 30 in.).

[1] Recent research, though not definitive, suggests that a home-burned CD-ROM will last approximately 3–50 years, depending on how it's burned and stored. The implications of this are sobering and I discuss them on pp.126–7.

biodegradable plastics for outdoor installations. All these techniques guarantee a very short life for the artwork and plenty of work – though with many ethical problems – for future restorers.

The idea of a short-term artwork was taken up by Andy Warhol, the clever graphic artist and manipulator of taste. He realised that built-in obsolescence in manufactured goods would increase the turnover and thus the profits of large firms; why not the same for the arts? In the past, it was very important how well an artwork was put together, and how it would stand up to centuries of use as an altarpiece, an inlaid timepiece or an escritoire. Art is, of course, perhaps the ultimate repository of human knowledge, skill and experience as well as an accurate recorder of the climate – moral, artistic and social – of the times. When the value of permanence is questioned and often rejected by a new generation of artists, the opportunity for future generations to study and enjoy their work is lost.

Modern sculpture often requires no more than the assembly of some *objets trouvés*; in the past, however, the choice of materials was a very serious business as a sculptor would often spend months working on a piece of stone or wood using traditional tools such as mallets, chisels, callipers and punches. It is a great pleasure to see the revival of woodcarving – that ancient art of church and refectory – by some contemporary sculptors, with its emphasis on certain woods for certain tasks. When I used to go to the Timber Council's offices for help and advice, the senior advisor would recommend: 'Look at the way Grandpa did it.' Grandpa was the inheritor of generations of specific knowledge relating to woods and their use in construction, from chisel handles to the most exquisitely carved wall panels. It is this explicit knowledge of the rightness of a material or technique for a certain task that often comprises a large part of the pleasure in art, for example a beautifully prepared piece of fruit wood for a woodcut, or a perfectly prepared scan for making a pigment print.

EXPERIMENTATION

I've always enjoyed experimenting with technique. When I was a student at art school, my tutor was exasperated by the way I was so often to be found grinding pigments, making up a chalk ground for a canvas, or reading about the materials of the old masters. Certainly, many great works have been made with a minimal knowledge of technique, a pencil on a piece of paper, or a couple of chisels and a piece of stone, and it's a good idea to keep the importance of technique in perspective: rather than an end in itself, technique should be an aid to achieving the artist's vision.

However, until very recently, the skill of a great painter was attributed to both vision and technical experimentation – the curiosity that drives people to unceasing research. If Vincent van Gogh had not been obsessed by pushing his work to the limit while constantly assimilating the work of others, we would not have his incomparable paintings today. Experimentation is what makes a daily routine of painting so fascinating, not the achieving of quick results that may or may not fetch a price in a fine art auction. Bear in mind that learning a complex technique, although challenging, will allow you to broaden your means of expression.

And one other point – the depiction of our personal vision of the world is fed by what we have seen, what our senses tell us; the art of painting is very much about realising this through long study and application. In recent years there has been a definite move back towards a more disciplined approach to painting. There are plenty of books about sloshing on acrylic colour, but it is well known that many of the most successful abstract painters benefited from a traditional grounding in analytical drawing, colour theory and perspective. There is a limit to how far one can go with free expression, and many painters want the expanded possibilities offered by a broader knowledge of technique.

Moulin d'Olc, oil on panel,
28 x 36 cm (11 x 14 in.).

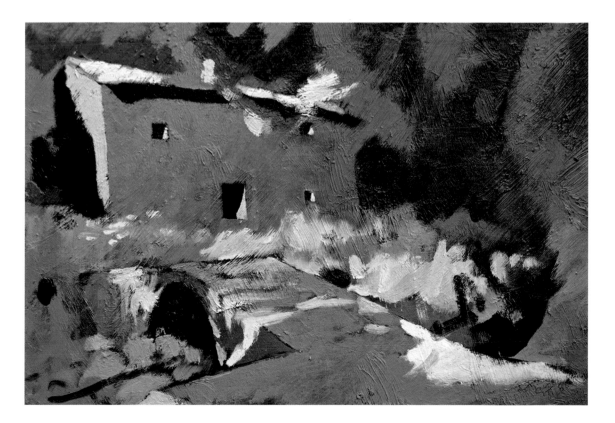

2
COLOUR

This book is not about the theory of colour, a very complex subject, but the following is a brief introduction to colour for artists. The names of colours follow a logical progression on the colour wheel that can be achieved by mixing paints. The colour wheel for the artist does not use the same terms as printer's colours or the scientific names for the spectrum – indigo for example, used by scientists to describe the colour between blue and violet in the spectrum, is an obsolete colour obtained from plants and used for dyeing cloth.

Primary colours
Primaries cannot be made from mixing other colours. They are:
- red (between red-violet and orange);
- yellow (between yellow-orange and yellow-green);
- blue (between blue-green and blue-violet).

Secondary colours
These are mixed from two primaries making:
- orange;
- green;
- violet.

It is surprisingly difficult to mix pure secondary colours – orange that is neither red or yellow but exactly between the two, violet that is neither blue violet nor red violet. To mix pure colours it is essential to have transparent pigments, which is why it is usually preferable to use the very best watercolours.

Tertiary colours
Tertiary colours are made from mixing a primary with a secondary colour:
- red-orange, orange-red, yellow-orange, orange-yellow;
- yellow-green, green-yellow, green-blue, blue-green;
- blue-violet, violet-blue, red-violet, violet red.

Complementary colours
Complementary colours lie opposite one another on the colour wheel. The complementary colour of a cool primary is a warm secondary and vice versa.

FACING PAGE: *Mecle* (detail), watercolour on Hahnemuhle 300 gsm paper, 56 x 76 cm (22 x 30 in.). Vivid blue indanthrene and phthalo contrasts against lightly applied reds and yellows in this watercolour.

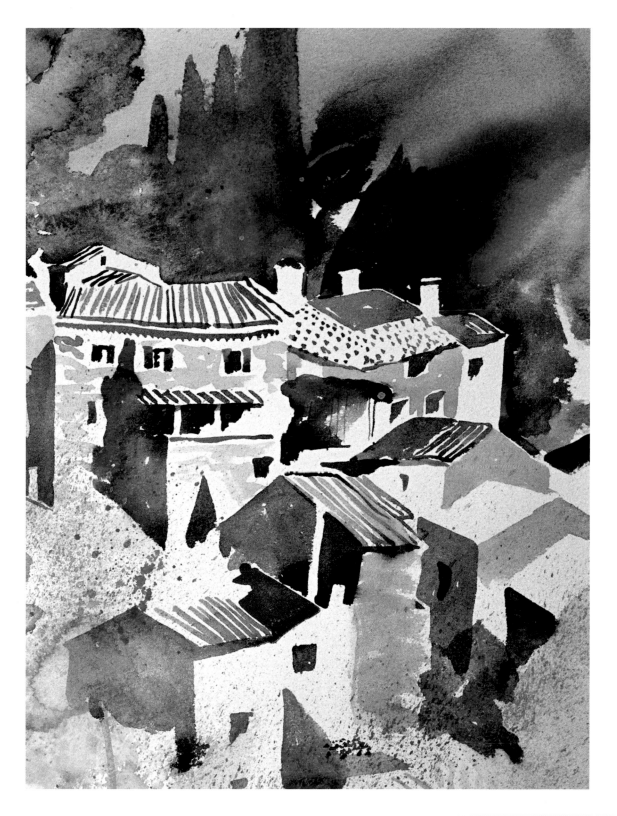

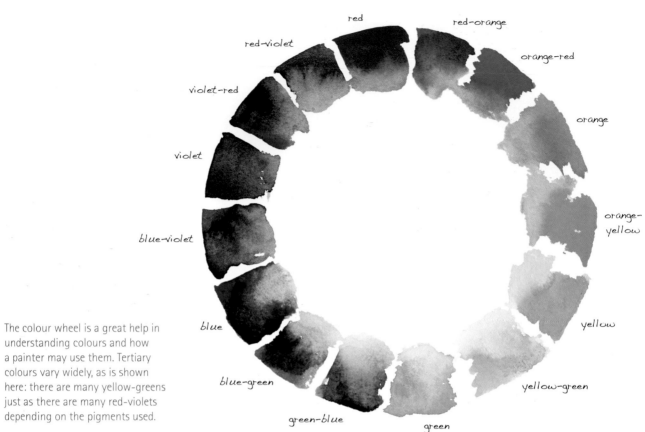

The colour wheel is a great help in understanding colours and how a painter may use them. Tertiary colours vary widely, as is shown here: there are many yellow-greens just as there are many red-violets depending on the pigments used.

Other features of colour

Colours have three principle characteristics:

Hue In artists' paints, this indicates a paint that is similar to another but differs in certain respects. For example, cadmium red hue replaces cadmium red (considered mildly toxic if ingested) with a non-toxic and less expensive pigment. We also sometimes speak of a colour as having a light red or a dark red hue.

Saturation is the strength of pigment or dye in a colour – when a colour is saturated it is at full strength, undiluted.

Brightness is the perceived intensity of a colour: a bright red in sunlight does not have the same brightness in shade. This principle is also used in tonal painting where tinting and shading of colours is used to produce lighter or darker tones of colours.

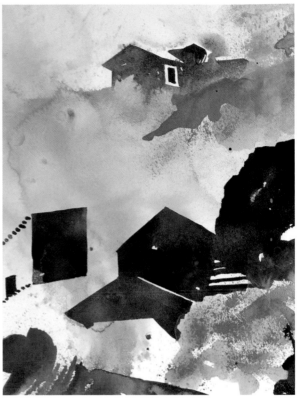

THE COLOUR INDEX

The Colour Index International[1] is a standard listing that classifies pigments by their chemical composition and gives them a colour index name code and a colour index number (which is seldom used on paint tubes). This allows you to research any colour on the Internet or in books. For example, raw umber, made of natural iron oxide pigment, has a CI name code of PBr7 and a CI number of 77492. (See pp.28–9 for the Colour Index key to pigment names.) For most painters it will be enough to know the CI name code, which is what most manufacturers print on packaging.

Paint manufacturers provide Colour Index information for their products, so you can identify which pigments are used in their colours. The pigment's CI name code and American Society for Testing Materials (ASTM) number[2] (which is widely used) should be shown on the tube or in the manufacturer's literature. If it's not, don't buy it!

[1] The Colour Index International is jointly maintained by the Society of Dyers and Colourists (UK) and the American Association of Textile Chemists and Colorists, and is used universally to describe specific pigments.

[2] ASTM rates lightfastness of pigments from I to IV: I being very safe; IV very unsafe.

ABOVE LEFT: This detail of *Cambous I* (p.51) shows tertiary greens and violets. The variations in the colours took place on the palette as I worked – painting is often about this continual adjustment of colour harmonies that occurs as the painting takes shape.

ABOVE RIGHT: Reds, yellows and orange earths are set off against a deep brown-violet in this detail from *La Courbe* (p.34).

The CI name code is sometimes printed on the packaging.

COLOUR

3
PIGMENTS

Paint is made from pigments. A pigment is a substance with a specific colour and a Colour Index name code. Nearly all pigments are sold in powder form but their origins can be very different. Many of the earth pigments, for example, are made from naturally occurring clays or rocks quarried from many parts of the world, whereas mineral, or inorganic, pigments are made from mineral deposits such as lead or copper. Many of our modern, permanent pigments are produced by chemical processes, and these are known as synthetic pigments.

To make paints for artists, pigments are ground with a binder. Different binders produce different types of paint (see paints listed on pp.38–49). A paint colour might have the same name as the pigment that produced it, or it may differ. Some colours come from the same family or group of pigments, for example the earth colours Venetian red, light red, Indian red and red iron oxide all have the Colour Index name code PR102 (see p.21).

It is possible to make some of your own paint from pigments (see pp.39–40 and 46–7), and you can buy these in good art shops. Pigments vary in the size of particles – some are coarse and hard to grind into colours, others are very powdery and fine in consistency and require little grinding. Some will make a paste easily when mixed with water, others resist this and will only slowly disperse. Some absorb a large amount of oil during grinding, others very little – indeed one common problem is too much oil in a colour. Transparency and opacity of pigments are natural qualities built into the pigment; cadmium red is always fairly opaque in whatever binder, quinacridone pigments are transparent, etc. Use the table of pigments on pp.20–21 to check that the pigment you are using to make a paint is lightfast.

EARTH PIGMENTS

At the heart of many painters' palettes are the earth pigments, indispensable colours made from iron (or ferric) oxides, manganese oxides and other

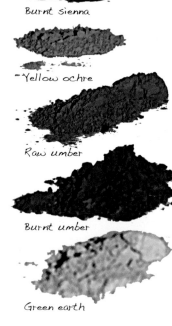

Burnt sienna

Yellow ochre

Raw umber

Burnt umber

Green earth

Dry earth pigments.

Early pigments such as those used in cave paintings were often clays, carbon or coloured earths that were mixed with various fats or naturally occurring binders such as chalk. It's known that Egyptians used gesso, plaster and mud and their pigments have proved remarkably lightfast (many were not exposed to light of course, as they were in sealed tombs). Most were earth pigments, red and yellow ochres for example, but they did use smalt, a type of cobalt blue and calcium copper silicate blue. Violet reds were rare.

Greek and Roman painting followed similar principles but their knowledge and the availability of techniques improved with the growth of empire – Imperial purple, for instance, came from shellfish found on the Atlantic coast of Africa.

naturally occurring pigments, often clay based. The main earth pigments are umbers, siennas and ochres.

Originally, earth pigments came from pits or quarries and were turned into paints in the artist's workshop. Well-known artists had young apprentices who were mainly occupied in grinding pigments for the master, and having a good supply of pigments was always a priority. The pigments were ground in an emulsion of egg and oil to make tempera, and various oils (such as poppy oil, sunflower oil or linseed oil, depending on the painter's preference) to make oil paint.

Another advantage of real earth pigments is that they usually dry quite quickly, so that the first layers of paint – the underpainting in classical technique sometimes called the *imprimatura* – are soon ready to take the next layer of paint. It is well recorded that in the 19th century in France, many painters preferred a yellow ochre *imprimatura*, especially for portraits. Interestingly, after meeting Rubens, Velasquez changed the colour of his *imprimatura* from brown ochre to a light grey, almost certainly a mix of white and earth pigments.

Using earth pigment colours

Umbers, natural and burnt, are iron oxides originally from Umbria in Italy – today most umber pigment comes from Cyprus. This darkens when heated or calcined: raw umber is simply heated on metal plates to various degrees of darkness to make burnt umber. This pigment is one of the most interesting historically, having been one of the base colours for innumerable masterpieces of painting. Yellow ochre and raw sienna are close cousins but produce different effects: raw sienna is slightly browner than ochre and produces fine biscuit oranges when heated, or calcined, as the process is also known. Of these, the best-known is burnt sienna.

Maimer Classico

Maimer Grezzi

Rowney

Schmincke Mussini

My hand ground burnt sienna

A comparison of burnt sienna oil paints.

COLOUR AND PIGMENT CHART

All the following colours are permanent enough to be used in the artist's palette

REDS		Pigment notes, Colour Index numbers	Comments
	Quinacridones Magenta Alizarin permanent Carmine Rose	PR122 is an excellent pigment group. Used by innumerable manufacturers.	Transparent, non-toxic, medium price range, strong tinting strength as an artist's colour.
	Cadmiums Cadmium red deep Cadmium red light	PR108 is used in bright vibrant reds and orange reds. It is used by all the better colour makers.	Semi-transparent in watercolour, mildly toxic if ingested, fairly expensive, strong tinting strength as artist's colours. Wash hands well after using it.
YELLOWS			
	Cadmium lemon Cadmium yellow Cadmium yellow deep	PY35 offers bright, beautiful colours from greenish lemon to orange yellow. It is used by all good colour makers.	Semi-transparent in watercolour, mildly toxic if ingested, fairly expensive, strong tinting strength as artist's colours. Wash hands well after using it.
	Winsor yellow	PY154/155 is close to cadmium lemon. Used by W&N for their Winsor yellow.	Fairly transparent, non-toxic, inexpensive, good tinting strength as an artist's colour.
	Arylide yellow	PY73/74 is also known as PY3 to PY10. Confusion surrounds this pigment which is known by many different names. See p.33.	Fairly transparent, non-toxic and inexpensive though not as permanent as Cadmium yellow. Good tinting strength.
ORANGES			
	Cadmium orange	PO20 gives a bright, strong orange from yellow-orange to red-orange.	Semi-transparent in watercolour, mildly toxic if ingested, fairly expensive, strong tinting strength as artist's colours. Wash hands well after using it.
	Quinacridone orange	PO48.	Transparent and unique colour, non-toxic.
GREENS			
	Chrome oxide	PG17 is a strong green on the yellow side.	Opaque, non-toxic, inexpensive with strong tinting strength.
	Phthalocyanine green (yellow and blue shades)	PG7/PG36 intense blue greens.	Transparent, non-toxic, medium priced with extremely strong tinting strength.
	Viridian	PG18 beautiful blue-green.	Permanent, transparent, non-toxic, medium tinting strength.

COLOUR AND PIGMENT CHART cont.			
GREENS		Pigment notes, Colour Index numbers	Comments
	Cobalt green	PG26/PG50 soft blue greens.	Semi-opaque, non-toxic, good tinting strength, very expensive. Cobalt turquoise, a mixture of cobalt green and titanium white, is a beautiful opaque colour that can be very useful in landscapes.
BLUES			
	True cerulean blue	PB35 is a lovely greenish blue; an ethereal colour.	Opaque, non-toxic, used very often for painting skies.
	Phthalo cerulean blue	PB17 is a beautiful, strong green-blue.	Transparent, non-toxic, high tinting strength, medium priced.
	Phthalo blue	PB15 is used in strong, dark blues on the green side. This colour replaces Prussian blue in most palettes.	Transparent, non-toxic, high tinting strength, medium priced.
	Cobalt blue	PB28 is one of the most beautiful of all blues.	Semi-transparent, non-toxic, good tinting strength, expensive.
	Ultramarine blue French ultramarine	PB29 a lovely deep blue on the red side.	Transparent, non-toxic, good tinting strength, inexpensive, an indispensible colour.
	Indanthrene blue	PB60 Intense dark red blue	Transparent, non-toxic with high tinting strength, medium priced.
EARTH COLOURS			
	Raw umber Burnt umber	PBr7 is in a huge range of colours, from deep red brown to pale green or yellow.	Mostly transparent, indispensible colours for the painter. Inexpensive and non-toxic.
	Yellow ochre Gold ochre Raw sienna	PY42/43 is another huge range of colours from pale yellow through warm brown to brown-violet.	Mostly transparent, indispensible colours for the painter. Inexpensive and non-toxic.
	Burnt sienna Venetian red Caput mortem (another name for Indian red)	PR102 is used in synthetic and natural red earths.	A mix of transparent and opaque colours. Inexpensive, these pigments give us reds and oranges from the brightest to the dullest.
	Naples yellow	PY41 lead-based yellow.	Opaque and toxic, this old colour is still used by some painters. Modern Naples yellow is usually a mix of white and yellow pigments.

A painting in progress on grey ground. Real earth pigments, such as this grey ground (made from ultramarine, burnt umber, red oxide and titanium white) dry quickly, making them very suitable for the *imprimatura* (see p.19).

Transparency

The best iron oxides, the natural clays from which earth pigments are produced, are often transparent as artists' colours. Burnt sienna, as watercolour and oil paint, is a beautiful lucid, hot red-brown, well adapted to glazing – as are many of the raw and burnt umbers. Green earth, also called terre-verte, is similar to some raw umbers and can be semi-transparent, while red iron oxides are less transparent than many earth colours, some of which are virtually opaque – such as Naples yellow.

Some years ago, I had an interesting correspondence with the colour-makers Winsor & Newton, when I noticed that the burnt sienna watercolour that I had just bought was slightly different from the older tubes that I had. After a most interesting debate, the company very kindly sent me a dozen or so small pots containing samples of the pigment from various parts of the world. Their tests to find one that really matched their old pigment had obviously been extensive.

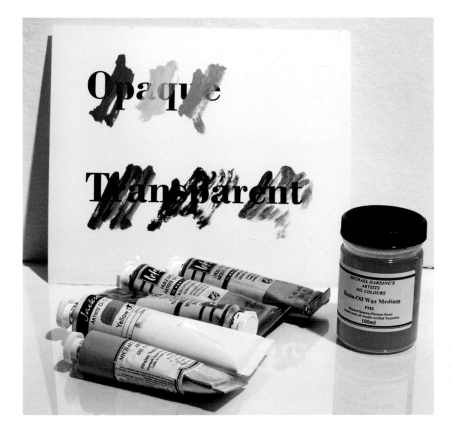

Cadmium red and yellow ochre are semi-opaque whilst quinacridone red, ultramarine and burnt umber are transparent.

Historic versus modern

A very few earth pigments are no longer readily available. The real Naples yellow for example, is made using lead ore from Naples, which is of course poisonous, and so what passes for this colour in our day is actually a composite colour. Be very careful to protect yourself if you are tempted to try the real colour. (One colour-maker, Kremer Pigmente in Germany, produces some traditional colours which are used in the restoration of period work and by painters who want to retrieve the colours of the past; and Michael Harding makes an excellent true Naples yellow and Chinese vermilion.)

The use of modern pigments to replace toxic or fugitive ones is readily understandable (as in the case of Naples yellow), but less so in the use of synthetic iron oxide. This has been used by certain colour-makers to replace the natural earth pigments and the paints, and in my experience, are not so bright and lively as the real earths and, importantly, lack the beautiful transparency of natural iron oxides. Van Dyke brown should never be used, as it is very impermanent.

Roussillon, Provence. Photo: AISPIX

Buying earth pigment colours

It is a good idea to experiment with earth pigment colours made by several different firms until you find the ones that you like best. In France, one of the best sources of good earth pigments is Roussillon in Provence, a beautiful village, if rather tourist-orientated. The quarries and workshops of this region have been making first-class pigments for years and it is a great pleasure to buy pigments and binders from here. The range of lovely warm earths is extensive and there are examples of how they are used both in painting and the decorative arts. It is also possible here to find pigments from other parts of France as well as colours from Cyprus (some of the best available) and rich, dark colours from Spain.

Projects

Using oil, acrylic and watercolour paint on white paper, make brushstrokes of the same earth colour, raw umber for example, to better understand the nature of the colour, how it behaves in the three different binders and how the same colour can be very different depending on the manufacturer. Studio colours for example have a lower charge, that is, have less pigment, than artist's colours.

For a better understanding of the character of various earth colours, you might also try the following.

- Make brush and wash drawings of a variety of subjects using sanguine (red iron oxide) or other earth-colour washes.
- Use earth-colour conté sticks or pastels for drawing the nude or portraits.

MODERN COLOURS

The bright colours that are available to painters in the 21st century are the result of a small revolution over the past 50 years. In Germany, towards the end of the 19th century, a new range of colours was produced by the Schmincke company to fulfil the need for newer, better paints. The Industrial Revolution brought sweeping changes to traditional manufacturing and pigments were no exception, with firms looking for large quantities of permanent colours for items such as household paints and clothing. German painters of the day wanted watercolours

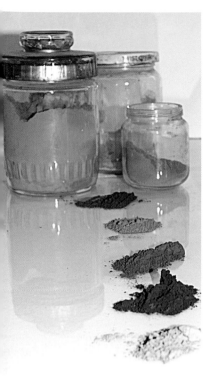

ABOVE: Earth pigments.

ABOVE RIGHT: A composition in burnt umber watercolour on Hahnemuhle 300 gsm paper, 36 x 56 cm (14¼ x 22 in.).

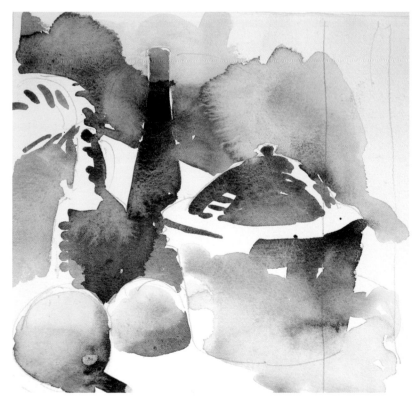

Monochrome wash and pencil.

MY PALETTE

For most painting media I use the following colours:

EARTH PIGMENT COLOURS

Raw umber and burnt umber;

Yellow ochre and gold ochre;

Naples yellow (imitation);

Raw sienna and burnt sienna;

Venetian red (I love this colour: in my view it is the best of the iron oxide pigments. It is similar to English red and light red, amongst many other paints based on the same pigment);

Caput mortem (another name for Indian red).

BLACKS AND GREYS

Lamp black (strong and fairly transparent; I use it occasionally for mixes and often for greys);

Ivory black (a beautiful subtle colour in washes as a watercolour; both ivory black and lamp black can be very important as neutrals in painting);

Davy's grey and Payne's grey (convenience colour mixtures; I prefer to mix these myself because grey can be either cool or warm and is often needed to balance strong colours or contrasts in a painting).

Gold ochre made by W&N | Yellow ochre from Roussillon | Raw umber from Roussillon | Red ochre from Cyprus

Burnt sienna made by W&N | Burnt umber from Roussillon | Indian red by Rowney | Green earth by Guardi

Ultramarine mixed with raw umber | Ultramarine mixed with umber and burnt sienna | Ultramarine with yellow ochre and burnt sienna

Variations of ultramarine mixed with raw umber and titanium white to make grey tones.

This list is not exhaustive and there are other earth pigment colours available, as well as the above carrying different names. The same pigment can differ according to the way it is processed by the manufacturer. I use inorganic iron oxides and not inorganic synthetic iron oxide because in general I prefer the character of these colours.

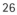

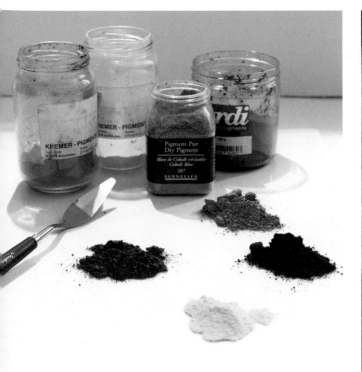

and oil paints that were brighter than the English and French ranges available; some of the newer pigments answered this need and some of the best-known expressionist paintings were painted with these German products.

A real advance was made more recently, with the systematic testing of pigments for lightfastness, toxicity and other qualities such as transparency and handling. The best paints now carry details of their pigments on the tube. You can also buy pigments to make your own paint (see pp.39–40, 46–7). These almost always come in powder form: do not breathe in the dust and remember to protect your skin.

NAMES OF COLOURS

The names of some colours are closely allied to their chemical composition; for others the name refers to a colour's history or other association. I prefer to buy paints whose name describes what they are – for example phthalocyanine blue, or cadmium red light – but some colour-makers give their paints odd or misleading names. For example the German company, Schmincke, uses the name Delft blue for a colour made using the pigment indanthrene; Winsor & Newton uses the name Winsor blue for what is commonly known

as phthalocyanine blue. So if a colour in a manufacturer's range seems to be carrying a fancy name, such as monestial blue (Daler-Rowney) or Blockx blue (Blockx), before you buy it, look for the Colour Index name and number on the tube or in the catalogue in order to check its pigment composition. In the case of these last two colours, both have a CI name code of PB15, and the pigment they are made from is phthalocyanine blue.

CHOOSING PAINTS

As well as English and American colours, I like the French Lefranc & Bourgeois oil paints and also some of the colours made by Talens, the Dutch colour-makers (see pp.135–7 for a complete list of recommended paint manufacturers). Oil paints made by the English firm Michael Harding are very high in pigment strength; they are quite pricey but well worth the extra money. Choice of paints is dependent on personal preference, price and availability, but earth pigment colours are among the cheapest and the most permanent. Always buy the artists' grade of paint if you can afford it – the students' grade of paint contains too much extender and not enough pure pigment, as you will see if you ever attempt to grind your own.

A sample of colours from Michael Harding.

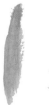

Naples yellow, dark Naples yellow, light Chinese vermillion lapis lazuli alizarin phthalo blue lake phthalo green lake phthalo green shade phthalo turquoise

BLUE

The traditional blues available in the 19th century – Prussian blue, cobalt blue and ultramarine – are all strong, bright colours and permanent. Cerulean blue, made from cobalt stannate (not to be confused with phthalocyanine cerulean blue, about which more later), was first isolated by a German chemist, A. Hopfner, but it was not until the 1870s that Rowney in England came up with a commercially available version of this beautiful clear, semi-opaque colour, which is especially useful for painting skies; its name is probably derived from the Latin word for sky.

Ultramarine, also known as French ultramarine because it was developed by the French, was first announced in the 1820s as a replacement for the expensive mineral pigment lapis lazuli, and has become probably the best and

Bini Bendc Djerba, 2001, watercolour on Saunders 300 gsm rough paper, 30 x 30 cm (11¾ x 11¾ in.). An example of a granular blue watercolour.

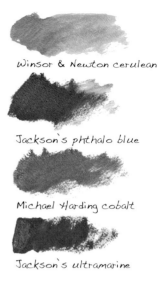

Winsor & Newton cerulean

Jackson's phthalo blue

Michael Harding cobalt

Jackson's ultramarine

A range of blue colours.

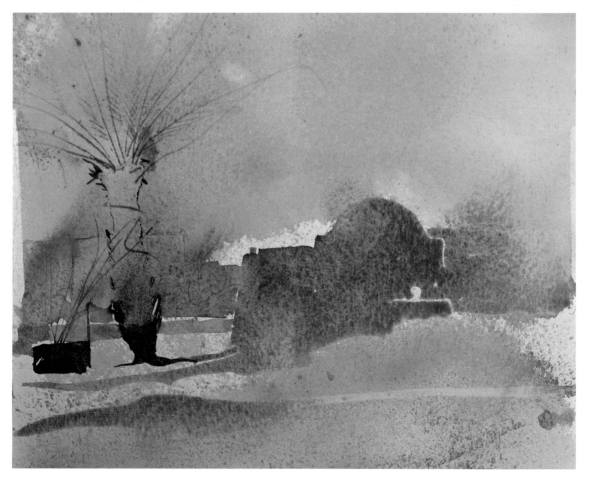

most popular blue pigment. Inexpensive, permanent and intense, perhaps the only criticism of this marvellous colour is its tendency to granulate as a watercolour. Interestingly, Michael Harding is now producing an affordable lapis lazuli oil paint.

Cobalt blue, also developed by the French, is one of the purest and most beautiful colours. This expensive new pigment was available in Paris when J. M. W. Turner passed through during the brief peace of the Treaty of Amiens in 1802, and he returned to England with a supply. It is well recorded that Turner would use anything he could get his hands on, but luckily for us, cobalt blue has proved extremely permanent.

The first cheaply available blue was Prussian blue, so called because it was used to dye the uniforms of the Prussian army. A strong green-blue, it is fairly permanent and intense but has largely been superseded by phthalocyanine blue, which is a purer and cleaner pigment. Phthalocyanine pigments were produced in laboratories and first commercialised by ICI in Scotland. These blue and green pigments have become a staple of most artists' palettes. Like Prussian blue and Prussian green before them, they can be 'palette killers' – dominating all other colours – and so need to be treated carefully. However, they are wonderful mixers, especially with earth colours. Particularly good are the phthalo cerulean paints now being produced by several colour-makers, which are strong, transparent and beautiful.

Indanthrene blue (or indanthrone blue) is a very dense, deep blue-violet with a high degree of permanence. I use it for shadows and greys.

RED AND YELLOW

Permanence has long been the problem with reds and yellows, and colours such as scarlet lake[1], alizarin crimson and Indian yellow have caused much of the best work in the last 100 years to fade dramatically. (One exception within the family of older bright yellow pigments is aureolin, which is a cobalt pigment. It is fairly permanent and has beautiful qualities as a glazing colour or as a watercolour.)

The big breakthrough in the permanence of bright red and yellow colours, however, came with the introduction of cadmium pigments towards the end of the 19th century. Although they were invented in mid-century, it was not

[1] Scarlet Lake, the name of an old fashioned fugitive pigment, is sometimes used, confusingly, to describe modern, better products.

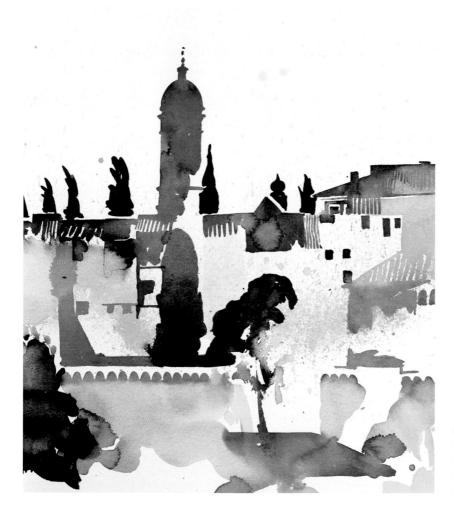

Quirico (detail), watercolour on Hahnemuhle 300 gsm not paper, 56 x 76 cm (22 x 30 in.). This is an example of very permanent yellows and reds.

until the 1880s and 1890s that these paints became readily available – and how lucky for us that they did so! You have only to look at the difference between the chrome yellows used by Vincent Van Gogh in some of the sunflower paintings, for example (which are now a warm brown), and his use of cadmium yellows (which are still bright yellow), to realise that without these pigments we would not have a proper idea of how great a colourist Van Gogh was.

Monet, too, used the new cadmium yellows and cadmium reds for his paintings, sometimes replacing the fugitive, beautiful traditional colours such as rose madder. However, the cadmium pigments – wonderful lemon yellow, deep yellow, scarlet, orange and deep red – are all on the yellow/ orange/ red side of the colour wheel, and this means that they will not make satisfactory violet tones when mixed with blue. It was largely for this reason that the beautiful, though rather fugitive, alizarin crimson (PR83; a pigment produced from coal derivatives) continued to be used, and is still offered by many of the

If you want really bright, permanent reds and yellows cadmium pigments, closely followed by the Arylide yellows, are the best on the red orange side of the colour wheel.

most reputable firms. Here I must add that although I love the colours that have replaced alizarin crimson to a large extent, I have yet to see a modern colour that can match its beauty. Michael Harding's alizarin crimson artists' oil colour is particularly fine. If you can't bear to do without it, make sure that you don't use it in thin washes as a watercolour: it fades fast! Napthol, azo and lithol reds are less permanent than cadmium and quinacridone.

Quinacridone reds

In the early 1950s, scientists began experimenting with new red and violet synthetic pigments called quinacridone. These have proved not only to be very permanent but also well adapted for all paint media.

The importance of permanence in red pigments is demonstrated by car paint. I remember seeing old cars that had once been bright red and were now a dull, faded pink because the pigments used were not lightfast. Sports cars, their tops down, racing through sunlit landscapes, are exposed to very strong light and research done to provide pigments for car paint that would stand up to strong light has been of great service to painters.

The importance of the quinacridone pigments – magenta, permanent alizarin, permanent rose etc. – is that they are on the blue side of red on the colour wheel and complete the list of absolutely colourfast pigments and dyes (see pp.20–1) available to the painter. This means that whereas formerly, a violet mixed from alizarin crimson and ultramarine would fade to a blue, we can now mix strong red-violets and blue-violets using quinacridone red.

Quinacridone pigments now replace all the old and unreliable crimsons, madders, lakes and red-violets, although it is annoying that these excellent pigments sometimes carry the names of the impermanent colours they replace. I can only hope that the dialogue begun by a few of us some years back will eventually lead to colours being sold as what they are, with a clear description on the packaging.

A range of Quinacridone colours

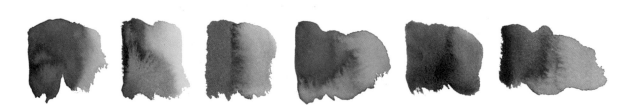

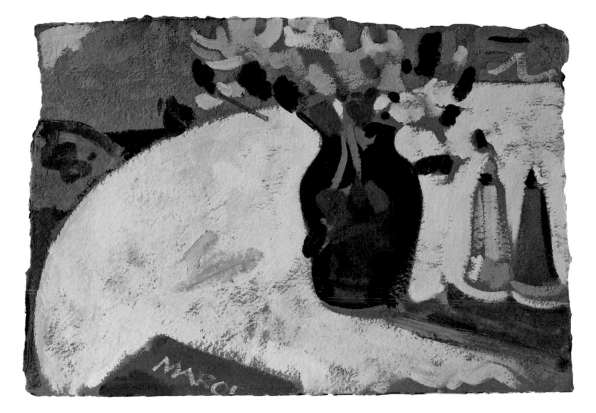

Pyrrole reds

Even newer are the pyrrole reds (PR254) recently developed by industry for commercial use on cars and in exterior paints, etc. These are proving extremely permanent and powerful.

Arylide yellows

The bright yellows – arylide yellow, arylamide yellow or hansa yellow (PY1; PY3) – are cheap, strong and easily available colours with fairly good permanence. Although apparently not as lightfast as cadmium yellow (PY37), recent testing indicates that the permanence of these has considerably improved. Also of special interest is lemon yellow (PY31): the paint that I tested, a very reasonably priced oil paint by Jackson's, is very nearly as bright as cadmium lemon (PY35), and very lightfast but less than half the price. It is difficult to be sure about these pigments because their permanence rating is now being upgraded as artists' colours: hansa yellow (PY73) is now claimed by some to be ASTM 1 (i.e. very lightfast). Plus, there is some confusion as to whether hansa yellows should be classified PYI or PY73 (PY73 is used in this book). Hansa yellow was the name given to pigments developed in Germany around a hundred years ago, and the name still applies to a family of pigments of a similar chemical structure, some of which are now considered very

Red cushion, oil on hand-made 300 gsm paper, 36 x 56 cm (14¼ x 22 in.). The paper was prepared with a gesso ground.

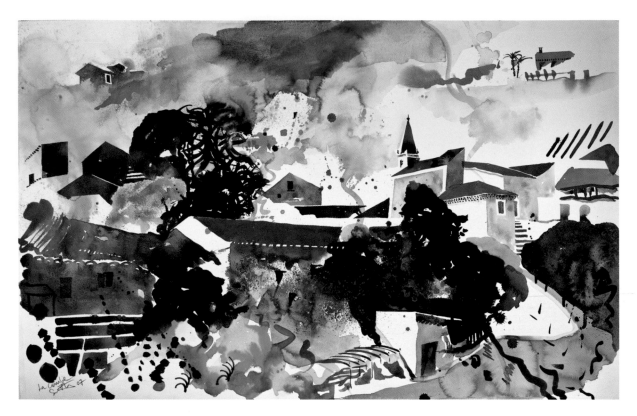

La Courbe, watercolour on Hahnemuhle 300 gsm fine 100% cotton rag paper, 70 x 100 cm (27½ x 39¼ in.). An example of primary colours dominating a painting.

permanent. This situation is typical of the evolution of paints currently taking place. The pigment benzimidazalone (PY154), used in Winsor & Newton's Winsor yellow, is extremely lightfast and a very good colour, and replaces a fugitive pigment formerly used for this paint.

Choosing reds and yellows

It is not always possible to decide to use only the best, most permanent pigments, because many are expensive and for a large work they can cost a good deal of money. Perhaps the simplest solution, if cost is an issue, is to stick to a selection of very permanent and inexpensive colours that include all but some of the brighter reds and yellows. See the suggested palette colours on p.37.

GREEN

Most painters use at least one or two manufactured greens. Cadmium lemon and phthalo green will produce the most brilliant greens; umber and ochres mixed with phthalo green create magical, rich colours. Recently, certain colour-makers have started offering phthalo greens in either a blue shade or a yellow

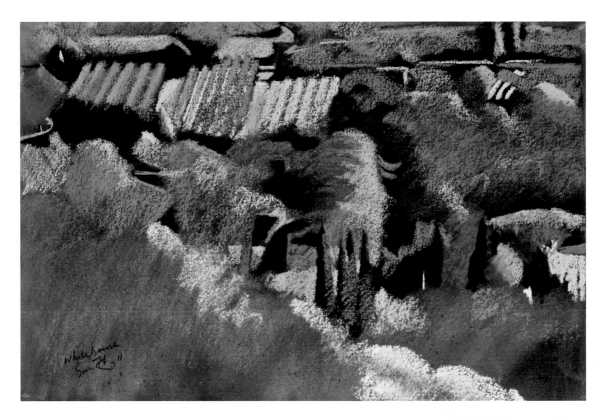

shade – the yellow shade is most useful for mixing vibrant greens; phthalo blues, either in a red shade or a green shade, are also available.

Viridian is a lovely atmospheric blue-green, very permanent, and until the advent of phthalo green it was indispensable. As an oil paint it is very useful for soft effects, but does not have the tinting strength of phthalo green. I also use a chromium oxide green, which is opaque and permanent, for mixes against bright primaries.

Cobalt green and cobalt turquoise are soft blue-greens and can be very beautiful. They are completely permanent, but expensive. You can make a similar colour to cobalt green by mixing phthalo green with a little white and blue. However, I find cobalt turquoise is irreplaceable for certain uses.

There are also plenty of unreliable greens, such as Hooker's green, and this is one of the problems that besets the serious painter. Hooker's green is still sold under that name but is no longer the fugitive mix of Prussian blue (fairly permanent) and gamboge (fugitive) that it once was: it is now made with phthalo blue and cadmium yellow – so why still call it Hooker's green? Sap green, olive green and permanent green can all be mixed yourself using a well-balanced palette (see p.37).

The White House, pastel on handmade paper, 38 x 57 cm (15 x 22½ in.). This painting uses a range of greens.

WHITE

White pigments are used extensively by all painters except watercolourists, who pretend never to use them! In fact, some white mixed with watercolour can add much depth to a painting. The most common, permanent and available white is titanium white: it is very white, very opaque, probably the best and most useful of the white pigments, and is made in vast quantities for industry (it is reckoned that pigments used to make art colours account for less than 5 per cent of world pigment production).

Zinc white is the pigment used to make the watercolour called Chinese white. It is semi-opaque, rather cool, inexpensive and permanent, and also very useful for mixing flesh tones in oil.

Flake white (also known as lead white or cremnitz white) is a stiff, cool white. It is toxic and should be handled with great care: it's better to use titanium white than to risk harming yourself with flake white; however, for flesh tones, flake white is much more sensitive and can be bought from Michael Harding. Lead white was used as make-up by Roman ladies and caused skin cancer.

Projects

- Using yellow ochre, burnt umber, ultramarine and titanium white, try mixing cool and warm greys for an interior or still life. Mixing greys is the key to using colour expressively.

- Using cadmium red, mix it with three other colours from the palette to develop a range of tones for a landscape. This will enhance your palette knowledge of mixing.

MY PALETTE FOR WATERCOLOUR, OIL AND ACRYLIC

If you are unfamiliar with artists' colours, this palette is quite sufficient for most purposes[2]:

- Cadmium lemon, cadmium yellow pale, cadmium yellow deep

- Cadmium red deep, cadmium red light

- The following Quinacridones: magenta, alizarin permanent, carmine, rose

- Ultramarine, also called French ultramarine

See also table on pp. 20–21.

- Cobalt blue deep

- Phthalo blue, phthalo cerulean blue, phthalo green. (Some colour-makers produce a green shade and a blue shade of both phthalo blue and phthalo green.)

- True cerulean blue

- Indanthrene blue

- Chromium oxide green

EARTH COLOURS

- Raw umber and burnt umber

- Yellow ochre and gold ochre

- Naples yellow

- Raw sienna and burnt sienna

- Venetian red

- Caput mortem (another name for Indian red)

A BASIC PALETTE

For beginners, I would suggest a starter palette of the following:

Cadmium yellow pale

Cadmium red medium

Quinacridone rose

Ultramarine blue

Phthalo blue

Phthalo green

Burnt umber

Yellow ochre

Venetian red

Tip

If you can't afford cadmium yellow look for cadmium yellow hue PY73. Be careful before buying so called 'permanent reds' – they are often quite impermanent! PR112, napthol red rated I–II ASTM, is fairly permanent and cheaper than cadmium red.

[2] Note that these are the pigment names and not the various different names given to these same colours by manufacturers.

4

USING PAINTS

As we have seen in the previous chapter, pigments are in principle inert, inalterable powders made from a variety of substances, from coal to clay and minerals. What people sometimes don't realise is that the paints that we use in the creative process (or for the decoration of our home) vary only according to the binding medium used: an ultramarine pigment can be turned into watercolour, acrylic or oil paint depending on what it is mixed with.

All painting media are different and have their own particularities, but in each case we want to know that we are using the most suitable and best material that we can afford. I am sure that all aspiring painters know the feeling of bewilderment at being confronted by the vast number of products now available in large art stores – so many types of paint, so many colours to choose from and descriptions that are unintelligeble to a novice! Yet many of these products are in principle quite simple – some can even be made up at home using everyday ingredients found in the kitchen or workshop – and with a little guidance you can be painting using good trustworthy materials known to painters for generations.

OIL PAINT

Oil paint was developed in the Low Countries (modern day Belgium, the Netherlands and Luxembourg) in the 14th century and quickly replaced earlier paint media due to its attractive glossy surface, durability and versatility. Early paints were made of hand-ground pigments that were mixed in a variety of oils. The method of making oil paint has changed very little since, although the advent of machine-made colours means we now have a huge list of colours to choose from. Because it dries quite slowly, oil paint can be 'worked into' over quite long periods. In thin coats it can be glazed when touch dry.

Binders

For painters working before the Industrial Revolution, a knowledge of how paints were constituted was vital not only to the painting process, revealing the way that paints handle on paper, canvas or board, but also for the permanence of the finished product. Amongst the earliest paint recipes we find linseed oil used as a binder, and this is still a very common ingredient in oil paints, both for painting and decoration. Other oils, however, have been widely used, among them poppy oil, giving a buttery feel to the finished oil paint; sunflower oil, which is lighter and clearer than linseed oil; and walnut oil, which is rich and unctuous.

Making oil paint

You can make a usable oil paint by grinding pigments in oil, either with a muller (a flat-bottomed chunk of glass) on a heavy slab, or in a mortar with a pestle, but note that oils are the hardest paints to make well (compared with basic acrylic, tempera and encaustic colours, which are all fairly easy). It is difficult to make an oil paint with a pleasant texture using linseed oil without a great deal of grinding, so I replace up to 30 per cent of the linseed oil with poppy oil before starting, which gives the paint a better consistency. However, there is little point in trying to reproduce colours at home that can be bought in tubes. Grinding colours is hard work and only appropriate really when done for certain specific uses – for example to make a coarsely ground watercolour (see 'Making Your Own Paint', pp.46–7) or an oil paint that is less unctuous than certain bought paints, some of which have an excess of binder. Nowadays most of us buy paint in tubes and are not too bothered about the oils used and reputable colour-makers pay close attention to the ingredients in their more expensive products.

Painting medium

A painting medium is useful for obtaining a smoother finish on brushwork. It is usually a mixture of alkyd resin, oil and wax, such as Winsor & Newton's Liquin. However, if I don't have any, I make up a mixture that consists of turpentine with some soft beeswax dissolved in it and add a few drops of poppy oil and dammar varnish. I never use white spirit (a petroleum product), only real turpentine (pine resin). There is some evidence that white spirit can be corrosive in paintings, but the main reason for not using it as a painting medium is that it dries so slowly. Turpentine dries quickly and has a pleasant smell.

Drying agents

You can mix a drying agent, or siccative, with a painting medium to speed up the drying time of certain paints. If too much drying agent is used with oil paint, it can cause the paint to crack; but for paints which are ground in an excess of oil, a few drops can save the frustration of waiting for days before those colours are dry enough to work over.

TEMPERA

Tempera paints have a very long history: they were certainly used in Ancient Egypt and possibly before this. The Egyptians produced tempera by mixing pigments with an egg and oil emulsion. The paint dries to a hard film, and provided the pigments are lightfast and a hard support is used is extremely durable. One of the advantages of this media is its immediacy – once the emulsion is made up, paints can be mixed and used with the minimum of fuss. However, it has largely been superseded by acrylic, which has similar properties.

Binders

Real tempera is an emulsion made using a whole egg, the same volume of oil (linseed or other), varnishes and other oils depending on the required consistency. Anyone who has made mayonnaise will understand the process: the oil and egg must first amalgamate as an emulsion. Once this has taken place, some water can be added if the mixture is found to be too stiff, and then oil-based varnishes, until the liquid is smooth and shiny. The emulsion will not last for long because the egg will go off, causing the mixture to become runny and filling the studio with a bad smell! (When tempera paints dry, they leave a hard paint film that does not go off; however, care should be taken to ensure that the painting does not become damp, as this can cause mould to form on the surface.)

Making tempera

For those who want to make tempera paint, mix the emulsion with pigment on a glass slab. Certain pigments are better adapted to this process than others, and each painter must experiment to find his or her favourite. I remember spending hours grinding pigment with oil on a slab: as the oil was assimilated, I would add more pigment, and so on; however, some pigments need very little grinding before you have a usable paint, which might not have the fine, buttery consistency of a bought product, but is perfectly good for certain painting. With tempera (and acrylic, which would have been called a tempera colour a hundred years ago), most pigments can be mixed to a workable consistency using a palette knife with the appropriate binder in a few minutes.

PREPARING TEMPERA WITH A KNIFE AND SLAB

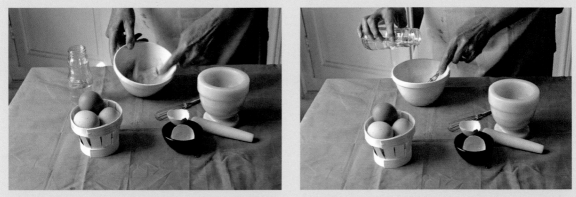

Beat one egg together with about the same volume of linseed oil to produce an emulsion about the thickness of mayonnaise. Add water if the mixture is too stiff.

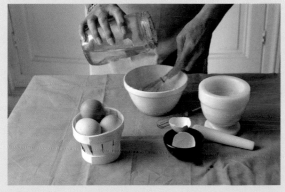

Add an oil-based varnish and mix.

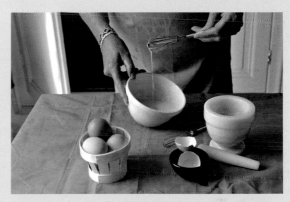

Add enough varnish to make a liquid with a smooth consistency.

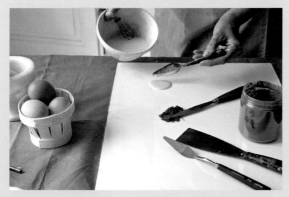

Spoon the binder mixture onto a glass slab.

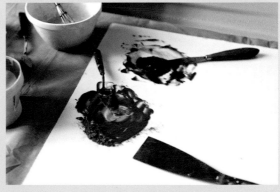

Mix in your dry pigment to create a smooth, buttery paint.

Distemper

In Latin, 'distemper' means 'to mix in the right proportion'. Distemper paints can be made from a large variety of binders, and I include it as a sketching medium because it's quick to prepare. (It is less suitable for painting simply because other, more reliable binders are now available.) You can make a basic distemper by frothing an egg white with a whisk and then mixing in pigments. It is best varnished when dry, as the distemper can sometimes peel off the paper.

Casein tempera

Casein glue is obtained from milk and is used in the same way as egg tempera. It can be used as an underpainting for oils or to make a finished work which is then varnished. Rather like egg tempera it is better used on a solid support like wood or card as it can crack when used on paper.

ACRYLIC PAINT

Acrylic paints are one of the most popular painting media and superficially resemble tempera. Developed in the 20th century from new synthetic glues, acrylic is water-based and dries quickly to a hard permanent surface. It can be applied either in thin washes or as a thick impasto to a wide range of supports. You can create many different and interesting effects when making your own acrylics by using the wide range of glues, varnishes and pastes available.

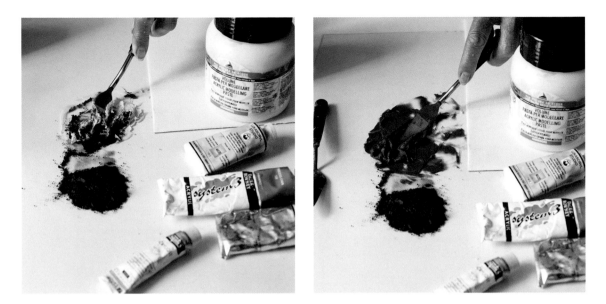

Binders

Acrylic binders are usually polymer emulsions, often of water with synthetic rubber or latex. If you wanted to make your own acrylic paints, ordinary wood glue is a polymer emulsion and is fine for making simple acrylic paints in much the same way as tempera: mix the pigment with the emulsion on a glass slab immediately before it is needed. Acrylic emulsions differ from tempera in that they harden to an insoluble finish – they can ruin a good brush if it is not thoroughly washed immediately after use.

Additives

There is an abundance of acrylic binding and painting media such as fillers, extenders and pastes to try and different methods to experiment with. I find that the most useful are the matt and gloss varnishes, as well as the basic emulsions, which can be used for a wide variety of effects including glazing and tinting. All of these products can be combined to glue collage, or to make impasto (coloured paste for painting) using sawdust or sand as bulk or for building up surfaces. There are also excellent ready-made pastes for impasto, and rollers for creating swathes or bands of colours.

Each painter must try the different techniques to find the one best suited to his or her needs. I have found acrylic very useful for grounds and underpainting, but I prefer the nature of oil paint and the fact that you can work on for hours without the colour drying on the palette as acrylics do. But for broad, bold effects on a large scale, acrylic is king.

USING PAINTS

ABOVE AND RIGHT: Mixing pigment to make tempera or acrylic paints.

BELOW: *Red hill*, acrylic and collage on canvas, 45 x 55 cm (17¾ x 21¾ in.).

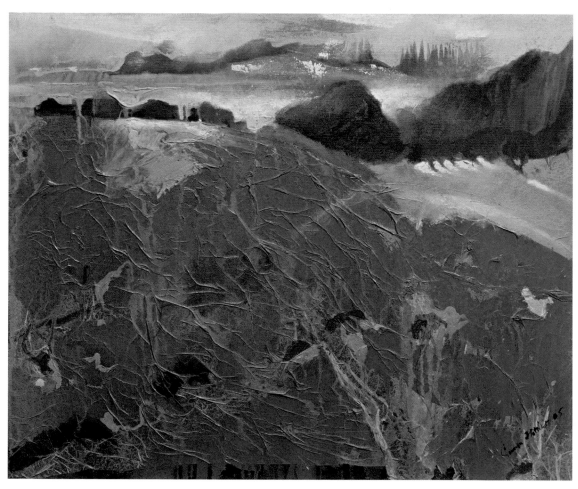

WATERCOLOUR

The first real watercolours were probably used in China to paint on silk, and this is one of the very oldest of paint media. The pigments are finely ground in water-soluble gums and can be applied in the thinnest washes – usually to paper – to create atmospheric scenes. Watercolour has recently been given a new lease of life by artists using stronger, more permanent paints, particularly in Germany and Austria.

Binders

Watercolours are made using a solution of gum arabic, fungicide, and glycerine or honey. The gum arabic binds the pigments together into a sticky mass, the fungicide prevents the paints from developing grey mould when moist (this can often occur, despite the presence of fungicides in pans of watercolour paints), and the honey or glycerine prevents the paint from drying in the pans or tubes. Occasionally ox gall (derived from bovine gall bladders) is used as a dispersing agent in watercolours. This brownish liquid causes better dispersion of the paint, but personally I find it unnecessary. Certain colours will disperse at different rates when mixed wet-into-wet on paper, but this is something that many painters use to obtain varied effects from their palette.

Working with watercolour

It is very difficult to make watercolours at home, as the pigments must be so finely ground. A very common fault with tube watercolours can be an excess of glycerine and this can sometimes be run off from the open tube. For very fine, small watercolours, holiday sketches, book illustrations and so on, half-pans, about 1.4 cm (9/16 in.) square, are fine – although if left for any length of time they will become hard, dry cakes of colour that have to be scrubbed to bring the colour back to life. Full pans, at 1.4 x 3 cm (9/16 x 1¼ in.) offer a larger quantity of paint which, when new, can be used for medium-format, 36 x 56 cm (14¼ x 22 in.) watercolours. For larger works, tubes or the extra-large pans offered by companies such as Blockx and Winsor & Newton are really the only answer. I was very glad to see the new 37 ml range of artists' watercolours from Winsor & Newton, as these really do make it possible to paint large works.

Watercolours should be diluted with water, but be sure that the water is pure and not contaminated with salts or chemicals. Sometimes it is necessary to varnish watercolours if the pigments are loosely bound: if some pigment comes off the paper when rubbed with a finger, the work can be varnished (although once a painting is framed, the glass will protect the work).

Tubes and various pans of watercolour.

Watercolour varnish is similar to pastel fixative: usually a light acrylic or oil-based gum in a solution (generally alcohol-based), which is sold as a spray.

MAKING YOUR OWN PAINT

I often make my own watercolour paint, and this is a specific and difficult task because the ingredients for the paint have to be just right. But why should I make my own when commercial paints are so good? The main reason is that coarsely ground watercolours give a particular texture to a painting and the earth pigments are especially beautiful in this respect; they are also cheaper.

Here it is worth mentioning that in general, pigments are perhaps too well ground by commercial manufacturers, leaving very little possibility of using the particular texture of certain pigments. Everyone who has ever painted in watercolour knows that ultramarine separates, forming granular watermarks on the paper, but perhaps fewer know that the earth pigments do the same if they are coarsely ground, forming beautiful patterns on rough paper for example. This was one of the favourite techniques of the German painter Julius Bissier, who painted abstract shapes on finely textured canvas using a palette of largely earth pigments.

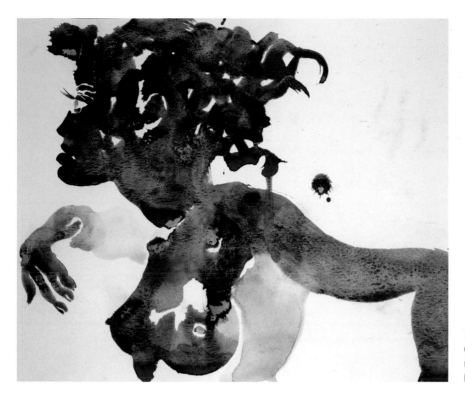

The Choice, red iron oxide on Bockinford 300 gsm rough paper, 40 x 60 cm (15¾ x 23½ in.).

Earth pigments can be easily mixed with acrylic binders to make a perfectly usable paint that costs practically nothing. For painting directly on boards or canvas, or for grounding papers, this is an excellent paint: permanent, quick-drying and great to work into either with oil, acrylic or pastel. If the paint is intended for fine work, it is a good idea to use a little retarder to slow the drying time, and to put the paint into screw-top jars where it will keep well for several days. See also 'Making oil paint', p.39.

Testing colours for permanence

When I was a student in England and needed tube colours, I would use mostly those manufactured by Winsor & Newton or George Rowney (now Daler-Rowney), but there is now such a vast selection of colours available to painters that it is difficult to know which to buy. I still tend towards the older, more experienced colour-makers, although I often test colours myself for permanence, especially watercolours. I was once given a nice-looking box of tube watercolours made by a Korean firm but when I tested them, many were disastrously fugitive, that is, not at all lightfast.

Testing your own colours is easy enough. On a good-quality support (heavy watercolour paper is ideal), paint a strip of thinned colour, then fix a cover strip of the same paper over half the colour and place the paper in a window in

the sun. After a few months, if the colour is fugitive there will be a noticeable difference between the colour as it was at the beginning, under the cover strip, and the other, exposed colour. The American Michael Wilcox produced a useful book some years back (Wilcox 1991), in which he published the results of tests made to evaluate permanence in watercolours, although, as has been pointed out by some colour-makers, he does not tell us what method he used for these tests. However, as a result of his crusade against alizarin crimson, certainly a fugitive watercolour in thin washes, there is now available a permanent alizarin crimson, a high-quality quinacridone pigment. The search for a permanent palette of colours has been the preoccupation of many painters for the past fifty years; often big advances made in pigment technology for industry have led the way.

Projects

- Making test strips as described above is a useful project as it will enable you to better understand the special character of each colour, how transparent or opaque, how well it covers, how intense each different colour is etc.

- Try using some of the older traditional colours like lapis lazuli, cinnabar (vermillion), azurite, smalt or verdigris to get a feel for these pigments.

GOUACHE

Similar in composition to watercolour, gouache has an addition of chalk to make it opaque. The best quality gouache paints are similar in their intensity to oils, although gouache has none of the luscious gloss of this medium.

Binder

Gouache is up to 50 per cent chalk made up with the same binder as watercolour, which, as well as making the paint quite opaque, makes the colours somewhat paler. Cheap gouache has very little tinting strength, whereas with the better brands beautiful effects can be achieved. Gouache is a waterbased medium and therefore suits painters who dislike the smell and texture of oil paint and want something without the transparency of watercolour. It dries fast and is easy to work into the dry paint, which can also be an advantage.

ENCAUSTIC

Another very old technique used from antiquity to the present day, encaustic creates a satisfying film of textured paint. It is produced by mixing pigments in hot wax, often with added oil or varnish, and was revived by American painters after the Second World War. Most painters prefer using acrylic to create a similar effect since acrylic dries hard while encaustic melts in warm temperatures, but its buttery texture is pleasing.

AQUEOUS DISPERSING PAINTS

Back in the 1960s, ICI produced a range of colours called Procion Dyes. These colours had unbelievable tinting strength and large quantities of highly coloured water-based washes could be made easily and cheaply with them. The patent was, I believe, sold to a German company, Bayer, and they are available today from certain colour makers but are more usual as fabric dyes.

5
GLAZING AND VARNISHING

Varnishes are not as popular now as they once were but they have several advantages. They can bring colours (especially dark colours) to life, they protect the paint surface where it is subject to pollution, and they can be coloured to change the effect of a painting – an earth-red varnish rubbed into the surface of a pale painting, for example, can bring it alive. See also 'Framing works on canvas or board', pp.116–19.

A half-varnished painting; the varnish has been tinted with raw sienna. *Victor Brox*, oil on canvas, 50 x 40 cm (19¾ x 15¾ in.).

GLAZES

One of the most valued qualities of watercolour is that it is painted in transparent washes over pure white paper, which gives a great brilliance to the colour. Adding layers of paint over dry work – wet over dry – is sometimes referred to as glazing. In oil painting, one of the oldest and most useful techniques is based on the same principle of using transparent glazes over a white ground. Alkyd resins create brilliant clear glazes and are also used for varnishes; they have become quite popular because of their fast drying time, but if you find them too glossy, thin them with oil or turpentine.

Make a glaze for oils

Here is a recipe for a glazing medium suitable for oil paint. Once the drawing and the first colours have been laid thinly on the ground, prepare the glaze. Measure out roughly equal quantities of dammar varnish, Venice turpentine and real turpentine (not white spirit), then mix them together. Venice turpentine

is a thick, gooey substance that should be left to dissolve in a little turpentine before adding the dammar. Add oil colour, either previously prepared or from tubes, to the glaze to obtain the required colour and then apply it over the dry work. Traditionally, this process can go on over a period of days or even weeks, building up a rich surface. The more Venice turpentine that is used, the warmer in tone the glaze will become. Keep the painting in a dust-free area, as dust will cling to the sticky glaze when it is wet. Add more colour to the glaze as required. Bear in mind the fact that very thick paint applied over varnish can crack or reticulate. This is the basis of resin oil colours.

Dammar varnish is cheap to buy, and can be used to thin paint to make a glossy overpaint or as a varnish for a finished oil painting (at least six months after completion). It dries quickly and is very clear.

VARNISH FOR OIL PAINT

Faugères vignes, watercolour on 300 gsm Hahnemuhle not paper, 36 x 56 cm (14¼ x 22 in.). A watercolour using glazes.

Besides dammar varnish (see above), modern synthetic oil resins, such as alkyd resins, are also useful for varnishing. Shellac varnish, often used to disguise dubious brushwork or drawing, is a dark, sticky fluid secreted by a bug and collected in India. It is sold in dry flakes that are dissolved in ethyl

alcohol to make a varnish. It is prone to cracking and is not recommended. Never use oil-based varnishes over acrylic paint. I always make a note of the painting medium used on the back of each board or canvas, to avoid making this sort of mistake.

GLAZES AND VARNISHES FOR ACRYLIC PAINT

Polymer (or acrylic) varnishes are often used to give a final touch to acrylic paintings but can sometimes bloom or whiten, thus spoiling the final effect. Make a test on an unwanted acrylic painting before going ahead. They can also be used as a glazing medium for acrylic painting in the same way as the resin oil colours described above.

Wax

A painter I used to know would work over the surface of his paintings, which were on canvas mounted on a panel, with beeswax into which he would work paint. This gave a high degree of protection as well as a unique effect. A little wax dissolved in real turpentine produces a painting medium with body. Petroleum-based wax is not recommended for painting.

An oil glaze over tempera.

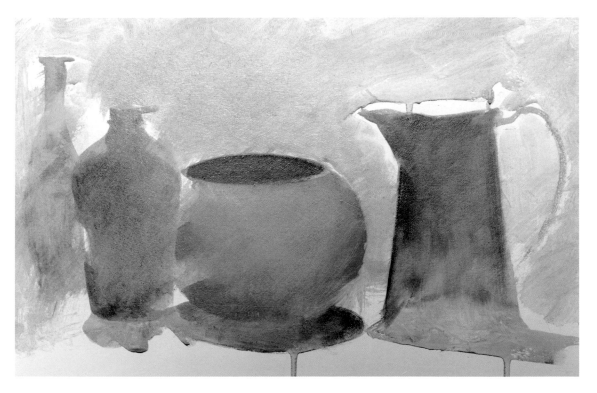

LEFT: Glazing mediums.

RIGHT: *Portrait of Julie*, oil on canvas, 40 x 50 cm (15¾ x 19¾ in.). Painted *alla prima* on a red-violet ground, the colours are so placed to take advantage of the *imprimatura*.

GOLDEN RULES

- *Never* use acrylic or another water-based medium over oil-based paints.

- It's fine and good to use acrylic-based paints as a ground for oil paint.

- Apply paint 'fat over lean'. This old adage still holds good for oil painting, and also for pastel and acrylic. The underpainting or *imprimatura* should be thinly painted and the picture gradually built up to the final touches, which can be made with quite thick paint.

Projects

- Make some grounds: mix acrylic paste with various pigments and in different thicknesses and apply to boards or panels. These can be used to paint on with oil or acrylic depending on the colours and effects you desire.

- Experiment with glazes for oil paints: mix thin paint films, using oil and glazing medium, and paint into the above dry grounds. Try to get the maximum transparency and texture into the work. This will increase your understanding of texture and transparency.

- Use watercolour over a dry acrylic brush drawing on paper. Glazing colours reveals texture and enrich the colour under the glaze.

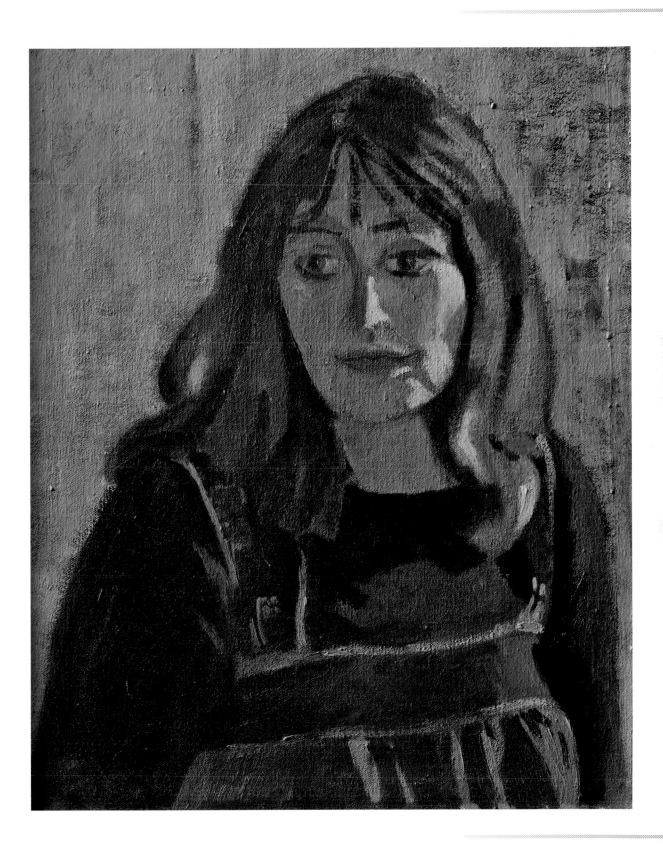

6
BRUSHES

A huge variety of brushes are available, from cheap packs in builders' merchants and supermarkets to the finest Kolinsky sable brushes worth hundreds of pounds. A brush is a highly personal instrument and no artist can anticipate whether a brush will become a favourite until they've tried it. The more expensive the brush, generally the more sensitive it is, but each painter should experiment with different makes and types. Often the type of hair used is not printed on the brush, so it's a good idea to look at the maker's catalogue to determine the materials used, such as hog hair, squirrel hair, sable, Kolinsky sable or synthetic. Most painters will have some squirrel-hair brushes for ink and watercolour, and some hog and sable brushes for oil and acrylic. There are also tough and useful synthetic-hair brushes available, and many are more resilient than traditional brushes.

Brushes for drawing.

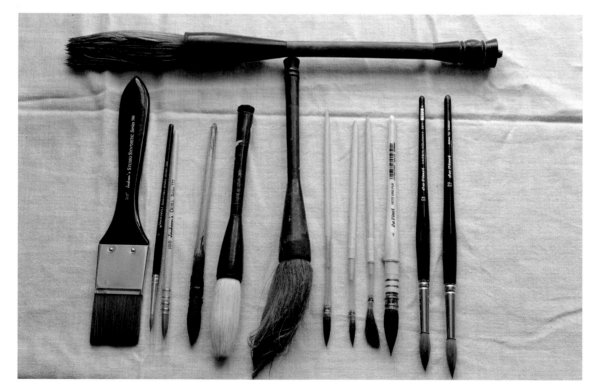

BRUSH DRAWING

Brushes for drawing are still little changed after thousands of years, but a good brush can be expensive and must be adapted to the style of work required. Brush drawing lies between drawing and painting and is one of the most interesting exercises for life drawing groups, as well as being a way of loosening up or for getting the broad outline of a composition before beginning with colour. Brush drawing with intense black Indian ink is especially useful for learning how to manipulate a brush: one of the basic methods needed for successful watercolour painting. After use, wash brushes thoroughly with soapy water, especially if used for Indian ink, and then rinse. Use your fingers to shape the hair into a point and leave to dry.

BRUSHES FOR DRAWING		
Type of brush hair	Use for	Notes
Hog	Mainly for oil and acrylic but can give interesting effects when used with Indian ink.	Available as cheap hardware goods or fine art brushes; prices vary according to quality.
Squirrel hair	Wash drawing, watercolour and gouache.	I tend to use these to make pure brush drawings. A reasonably priced, durable brush, is often good enough for all but very fine detail.
Petit gris (Siberian grey squirrel)	Wash drawing, watercolour and gouache.	Durable, much cheaper than sable and able to hold a large amount of ink, thus enabling full brush technique.
Sable	Wash drawing, watercolour and gouache.	Mainly used for fine work. The best sable brushes are very expensive. Some painters use only sable for watercolour and oil. Makes a distinctive mark; hold less paint than squirrel hair brushes.
Kolinsky sable	Beautiful for fine work as they hold a point well. I tend to use them to wash pencil or pen drawings, or for very fine detail. Also use for watercolour and gouache.	Made from hairs of the Russian or Kolinsky sable. Expensive. Hold less ink than petit gris brushes. Mainly used for fine work. The most expensive of all sable brushes.
Synthetic hair	Some are suitable for brush drawing, tempera or oil.	Often tougher than real hair and will keep a point for longer. Inexpensive and good for many uses, especially oil and acrylic.

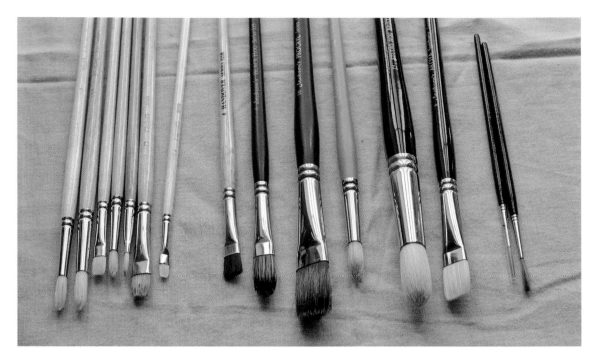

A selection of brushes.

BRUSHES FOR PAINTING

Good brushes are available from most of the bigger art materials manu-facturers but some of the best brushes that I have come from European brush-makers: Isabey of France, Da Vinci of Germany (their Kolinsky sable and squirrel-hair brushes are among the best), Raphael of France (good brushes for all purposes) and Jackson's of London (good value and a wide range of products). Daler-Rowney also make an extensive range of good brushes that are guaranteed for life.

Size and shape

There seems to be no industry standard for the size and shape of brushes, so I usually measure the size of the brush across the width where the ferrule (the metal or plastic tube which holds the hair in place) meets the hair, and describe them by the shape of the brush: flat, round or oval. Flat brushes have a squashed ferrule and the tip of the brush is square; in round brushes, the ferrule is tubular and the tip of the brush is rounded; oval brushes have a squashed ferrule and an oval tip. A spalter is a large flat brush made of squirrel hair used in watercolour painting; they are sometimes called flats.

For my watercolours, I use a number of round brushes from 4 to 25 mm; oval brushes of 10 and 18 mm; and two spalters, one of 12 mm, and one of 35 mm.

For oil and acrylic painting, I like to use a synthetic pointed round brush to draw the composition, but I prefer hog brushes for roughing in and long-handled sables for fine detail. Feathering brushes are useful for blending oil paint in fine work, some of the new synthetic flats – Jackson's brushes, made by Handover, for example – are very good for blocking in with oils; petit gris brushes (Siberian grey squirrel) can be used for glazing.

Care of brushes

It is important to take care of your brushes, especially if you have spent a lot of money on them. Once oil paint has dried on a brush, it is nearly impossible to remove. Sable brushes, in particular, should be very carefully washed immediately after use. Acrylic is the most dangerous paint for brushes, as it dries so fast. It is also important to note that solvents destroy the quality of good brushes.

For water-based paints, wash the brushes with soap and warm water, rinsing thoroughly. For oil paints, use turpentine or special brush-cleaning fluids, and then gently soap the hairs of the brush, working the warm water and soap into the hairs as far up as you can – the perennial problem with brushes is paint drying up near the ferrule, where it splays the hairs and spoils the shape of the brush. If you don't have time to wash brushes after painting, you can leave them for a short while in warm water. Boiling water should not be used to clean brushes, as it can dissolve the glue used to hold the hair together in the ferrule.

Cheap bamboo rolls are good for transporting brushes. Keep brushes in holders or a drawer, as they attract moths.

7
USING PASTELS

Pastel is certainly one of the oldest of artists' media, since in its simplest form it involves rubbing pure pigment on a surface: this can be seen in some cave paintings, and the murals of antiquity often contain work in pastels. Many fine chalk drawings were created during the Renaissance by Leonardo da Vinci (such as his early studies of drapes), Michelangelo and others, but after this period there were few drawings made using pastel techniques until the 18th century, when two brilliant exponents of the medium – Jean-Baptiste-Siméon Chardin and Maurice Quentin de La Tour – created a revival in France that spread to other European countries. Since then France has had a strong tradition of pastel painting and some of the best artists' pastels are still made there.

As we have seen in previous chapters, pigments are mixed with different binders to make oil, acrylic or watercolour paint, and the same is true of pastels. There are two main types – dry pastels (sometimes called artists' soft pastels) and oil pastels – but within these categories are many variations. Children's wax crayons are a type of pastel: these have to be non-toxic so a whole range

Home made pastels.

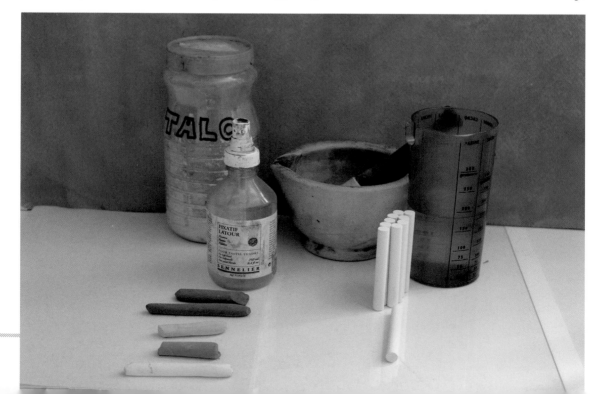

of special materials has been devised for their production and they are not usually suitable for artists' purposes.

Dry pastels are easy for the artist to manufacture in the studio with a few simple ingredients (see 'Make your own dry pastels', pp.64–7). Whilst making a pleasant, usable oil or watercolour paint is difficult, sometimes requires special equipment and is very time-consuming, good pastels can be made quite quickly and are sometimes superior to what we can find in art shops.

The support most widely used for pastel work is paper (avoid black velvet papers, which give kitsch effects), but boards, walls or panels can be used too. A coloured ground is usually applied to the paper before painting, but white paper can also be used for pastels.

Contrary to popular belief pastel colours can be at least as strong and vibrant as oil or acrylic but you must have the right pastels; many pastels sold are simply chalks with a minimal pigment content.

OIL PASTELS

Oil pastels can be hard or soft, depending on how they are made. For me, the best oil pastels (or oil sticks as they are sometimes called) are those containing plenty of pigment in a fairly softly composed stick, so that the quality of the pastel is slick and can be used almost like an oily brushstroke. These are actually similar in composition to oil paint, but with the addition of wax to give better handling. They can be diluted with turpentine to create washes on paper or canvas. One of the most popular and typical oil pastel is the Caran d'Ache product. These are quite hard sticks containing strong pigment and are good for small-scale work; there are many similar products available – check for pigment strength and CI name code.

Oil sticks.

DRY PASTELS (SOFT PASTELS)

Dry pastels can either be as hard as a crayon or soft and crumbly. The well-known pastel sticks made by the French firm, Conté, are highly pigmented dry pastels with a very good range of bright, mostly permanent colours. These are good for small coloured sketches, particularly when working out of doors, and for making life drawings (the red, or sanguine, conté stick is a staple of most artists, especially for small portrait studies). Dry pastels produce a good deal of dust so the drawing has to be fixed, blown or shaken to get rid of this. The hardness of the product does not lend itself to large works.

There is a large choice of good dry pastels made by Daler-Rowney, Schmincke or Sennelier, to name but a few. My preferred pastel stick is crumbly and soft, and has a very high proportion of pigment. These can be difficult to use as they sometimes fall apart beneath one's fingers, but the powder can be rubbed into the surface of the paper to rough in compositional elements, fixed and then painted over. Incidentally, I find that the rule of fat over lean applies to pastel painting as well as to oil and acrylic: if you begin your pastel work with too much pigment, the surface can quickly become clogged and has to be scraped down.

Pastel pencils, bought pastel sticks, and homemade pastel sticks.

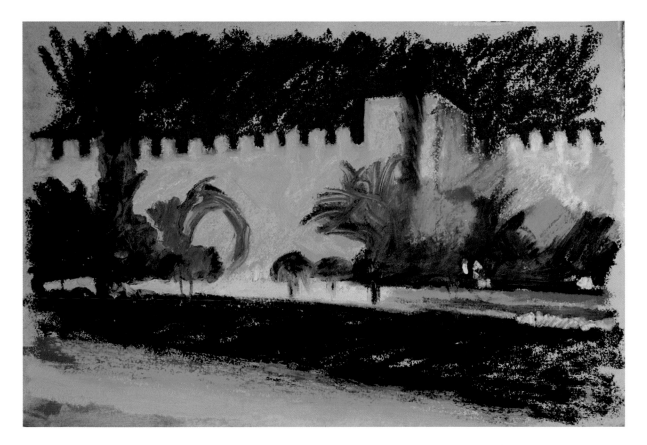

ABOVE: *The Guardian's Patch*,
oil sticks on handmade
paper, 34 x 56 cm (13½ x
22 in.).

Pastel papers, boxes of pastels,
fixative and a sketchbook.

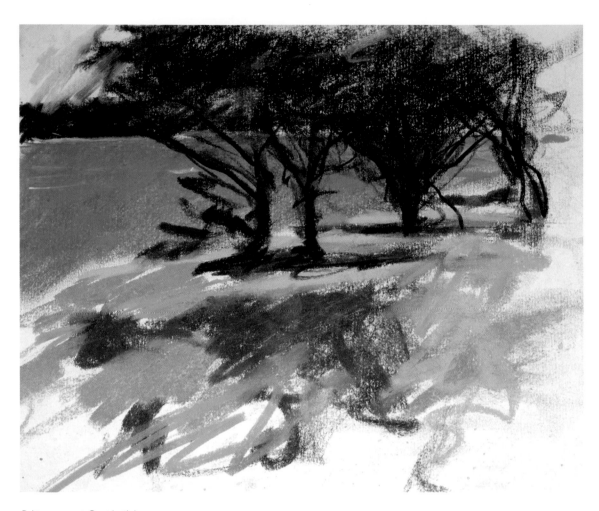

Brittany coast, Conté sticks on heavy, smooth cartridge paper, 30 x 30 cm (11¾ x 11¾ in.).

Make your own dry pastels

You will need pigments, binder and a couple of other additives. You can buy pigments from most art shops: Kremer pigments are good, as are Sennelier, but try to buy artists' pigments, which are more intense than students' pigments.

The most common binder in dry pastels is chalk. (Other types of dry pastels are slightly different. Coloured pencils use the harder china clay or pipe clay – generally the more binder that is used, the harder the resulting pastel is.) The following recipe uses blackboard chalk, produced by heating chalk and moulding it into sticks. These are crushed and wetted and on drying, will make the pastels harden. If too much chalk is used in a pastel, it will have low colouring power; if too little is used, the pastel will fall apart. There is no set recipe for the amount of binder, as each pigment reacts differently with water: earth pigments go very hard with too much chalk; an ultramarine pigment needs more binder.

MAKING A GREEN PASTEL STICK

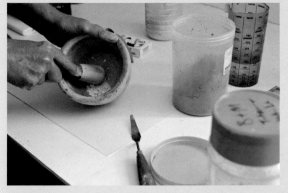

Crush the chalk in a pestle and mortar.

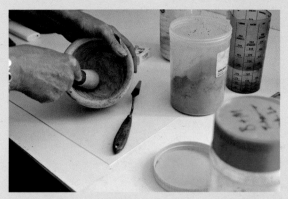

Add pigment and mix well.

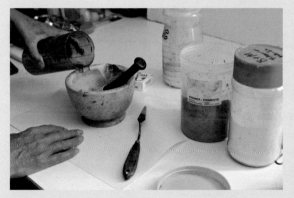

Add a little water to acheive a paste.

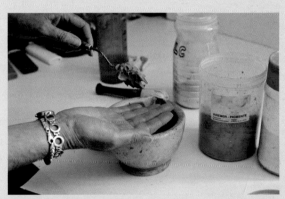

Scoop the mixture into your hands and loosely form a sausage shape.

When rolling it into a cylinder, we used a little talc to prevent the pastel from sticking to the paper underneath.

Project

MAKE A RANGE OF YELLOW OCHRE DRY PASTELS

You will need

- 2 measures* pale yellow ochre pigment
- 9 measures titanium white pigment
- 3 measures industrial talc
- 2 sticks of white standard, school-blackboard chalk
- Good-sized stone or glass pestle and mortar
- Glass slab

* 1 measure = 1 heaped tsp

1. Measure out the pigments and talc into individual heaps on a glass slab.

2. Put half a stick of chalk into the mortar and crush it to a fine powder with the pestle.

3. Add one measure of ochre, two measures of white, and one measure of talc. Mix very thoroughly.

4. Drop by drop, add tap water until, using the pestle to grind the mixture, you have a thick paste. The importance of mixing all the ingredients well can't be emphasised enough, as this is what will hold the pastel sticks together.

5. Use a palette knife to scrape the mixture from the mortar and then, with your fingers, knead it well on newspaper and roll it into sticks. Make the sticks whatever size feels right: some artists like fat ones, others prefer thin.

6. Leave the sticks at room temperature on newspaper until completely dry (usually at least 24 hours: don't be tempted to try and use them before they are dry, as they will break up). Repeat the process in the next two steps to make two further colour variations.

7. Take another half-stick of chalk, crush it in the mortar and add half a measure of ochre, three of white and one of talc. Proceed as before. This will give you sticks of a paler colour.

8. The last mix will use the remaining ingredients i.e. half a measure of ochre, four of white and one of talc, plus half a stick of chalk, to produce sticks that are paler still. You should now have a good range of colours.

You will also need industrial talcum powder, the product used on tyre inner tubes, which can be obtained from good hardware stores. This makes the pastel sticks smoother to use. Some recipes include gum tragacanth, a water-soluble gum obtained from the resin of thorn trees, but I have found that this makes most pastel sticks impossibly hard and unusable.

Some painters will find the recipe mixture too soft: if this is so, put each batch of sticks back in the mortar, re-grind them and add another half-stick of chalk. It is always a good idea to make pastel sticks in tonal batches of colours to avoid endless cleaning up, so make ochres and umbers one day, blues the next and so on, until you have built up a range of your own colours. You will soon find that you get a feel for how much chalk and talc is required once you begin using the sticks. In general, earth pigments are the easiest to make into pastels.

These home-made pastel sticks have a high percentage of pigment, which is not always the case with commercial products, and I have found that it is possible to get vibrant effects with them – redefining the phrase 'pastel shades'! You can make very large pastels for murals etc. at a fraction of the art shop price.

Tip

Be careful not to breathe in pigment dust when making pastels, and protect your skin from contact with pigments by using surgical gloves or barrier cream. You also need to protect your hands while working with pastels, as they dry the skin and cause it to crack badly, so a heavy application of barrier cream is strongly recommended before starting work.

FIXATIVES

To preserve the finish of a dry pastel work, it must be sprayed with fixative. This is a gum dissolved in a volatile liquid, usually petroleum or alcohol, and sold as pump sprays or aerosols. Before the volatile liquid evaporates, the fixative will darken the drawing, but after evaporation, the pastel will look much as it did before fixing. Be careful not to use too much fixative, as it can kill the lively tones in the painting. If you can't get hold of pastel fixative, you can use hairspray as a temporary measure. It's worth mentioning that chalk, when fixed, disappears almost completely because it has no pigment content so don't use too much of it! Note that fixatives are highly inflammable.

Pastel paper is one of the keys to success in this medium; insensitive or badly adapted papers can be unpleasant to work with and will not give a successful result. Black velvet or flocked papers are not at all to my taste but handmade papers and some watercolour papers can be excellent. Heavy tracing papers are very good but should be used on a backing paper as they are transparent.

USING PASTELS

67

La Voulte, pastel on hand-made paper, 30 x 40 cm (11¾ x 15¾ in.).

The great problem with pastels, especially if used thickly, is that if they receive a knock the colour can fall off the support, staining framing mounts and causing the work to lose vitality. For this reason, pastels should be stored flat with the image upwards, and moved as little as possible.

COMMERCIALLY AVAILABLE PASTELS

How many pastels do you need? I began with a small box of 36 Rowney soft pastels and you can go a long way with even so few colours. The great French pastel artist, Edgar Degas, used pastels in stripes (*zébrures*) to build up composite colour. Most pastel artists have several boxes and sort them according to colour: blues in one box, reds in another and so on. The following brands are recommended; there are also many other dry pastels on the market.

- *Daler-Rowney* Excellent colour strength and wide range of tints, although note that these are small sticks and unsuitable for large-scale works. On the hard side.

- *Sennelier* Beautiful colours and a wide range of tints. The sticks are crumbly and can be used almost like paint to make swathes of pure colour. Too soft for fine, small works.

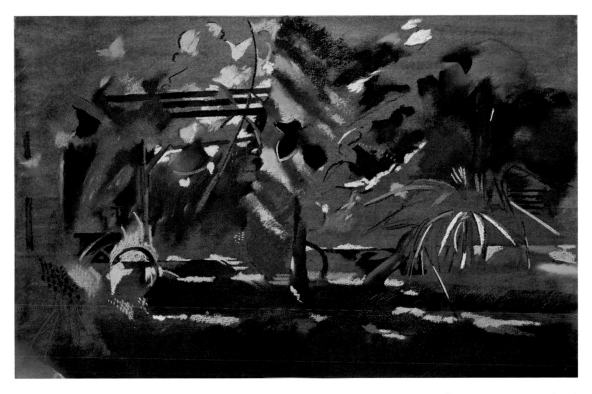

- *Schmincke* Good range of colours, with big sticks that are suitable for medium-sized work. On the soft side, though not as soft as Sennelier's pastels. Generally Schmincke use very good pigments but the use of PR112, Napthol, is a bit dodgy as it is not rated as fully permanent.

Permanent green, pastel and mixed media on handmade paper, 58 x 78cm (22¾ x 30¾ in.).

Project

This project will help you to understand the nature of soft pastels; good quality ones contain plenty of pigment and by rubbing this into the paper you begin to create a texture that makes for an agreeable surface to work into. But note that many of the finest pastel pictures in the history of the medium had a very thin pigment covering.

- Using the side of a soft pastel stick put a swathe of colour on a sheet of white paper. Rub this into the paper with a soft cloth to obtain an overall colour and then fix it. This is the *imprimatura*. Using charcoal or a hard pastel stick, make a drawing over this and then rub colour onto the paper to build up the work and composition. Add highlights and brighter colours with soft pastel sticks, and try to glaze the final colours over the previous work by using the pastel loosely.

8
MATERIALS FOR DRAWING

Drawing is the basis for nearly all forms of graphic and two-dimensional artwork and there are a huge number of different materials to choose from.

CHARCOAL

Charcoal is one of the oldest drawing materials, and still one of the best. It is usually made from burning willow (*Salix*) or lime (*Tilia*) sticks in a fire pit or clamp where the amount of oxygen getting to the fire can be controlled, thus causing the right degree of charring of the wood. The best charcoal is quite soft and will leave a rich black mark that can be rubbed into the paper with a finger or rag, or almost completely removed. Poor-quality charcoal is hard, leaves a scored mark in the paper and is usually a grey tone. Scene-painter's charcoal comes in big sticks and, if you buy the best brands, it is soft and black. The end of the stick can be sharpened on sandpaper to give an accurate point or edge. Be careful when choosing charcoal, as the thin sticks break easily and – an important point – cannot be used flat to make a swathe of tone.

Sharpening charcoal with a sandpaper block.

FACING PAGE, ABOVE: *Orchard*, charcoal on 400 gsm handmade paper, 75 x 100 cm (29½ x 39¼ in.).

BELOW: Charcoal sticks and a work in progress.

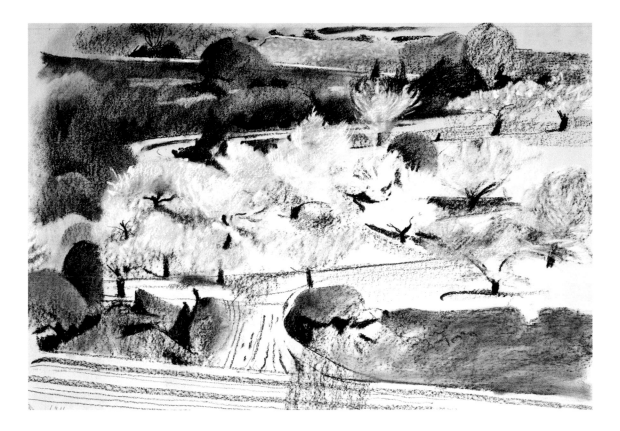

FACING PAGE: *Armelle*, charcoal and black chalk on French handmade cream wove paper, 50 x 32 cm (19¾ x 12½ in.).

Compressed charcoal is a hard, very black product made from charcoal dust and a binder. It is sold as sticks or charcoal pencils, but it is much harder than pure charcoal sticks, sometimes causing deep score marks in paper.

PAPER

Some artists prefer to draw on a toned paper and to use charcoal and a little white chalk (or, even better, white pastel) for highlights. The choice of papers is very large (see pp.90–3) but during workshops and seminars I often use ordinary brown wrapping paper, as the warm tone is suitable for many subjects – portraits, still lifes etc. – and these studies are often the beginning of compositions carried out in paint. Some of the greatest drawings have taken this form: many Renaissance painters made large, elaborate drawings, often on quite thin paper, to work out their compositions or to better understand a detail such as hair or drapery.

BLACK AND RED CHALK

Many of the finest drawings by the old masters were done in black or red chalk. This must not be confused with the cheap, poor-quality coloured chalks used on blackboards, which are made from chalk and low-grade pigments. Black and red chalks for drawing are really a form of hard pastel, like conté sticks (see below), and are made from clay, carbon or pigment and a gum binder. They are available either in the form of round or square sticks or (like the excellent pierre noir made by Conté) in the form of a pencil. These give the richest, darkest black of any drawing implement. They are made using ampelite, a natural mixture of clay and carbon; be aware that the marks made are nearly impossible to erase.

So-called stumps (tightly rolled paper tubes, probably from the French word *estomper*, meaning 'to shade down or blur') are very useful for blending marks on paper and for getting the finest greys, but all sorts of ancillary tools can be used for making drawing marks. I have seen shaved pieces of wood used to scratch marks into paper, and a good linen cloth is useful for rubbing and blending.

Conté crayons

Conté crayons were invented in the 18th century by a Frenchman, Nicolas-Jacques Conté, and today are made by the firm Conté à Paris.

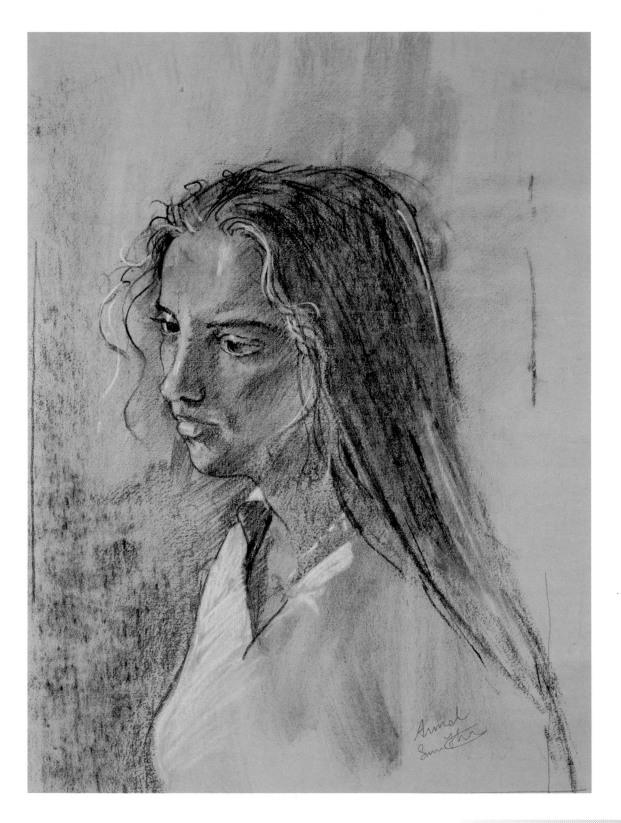

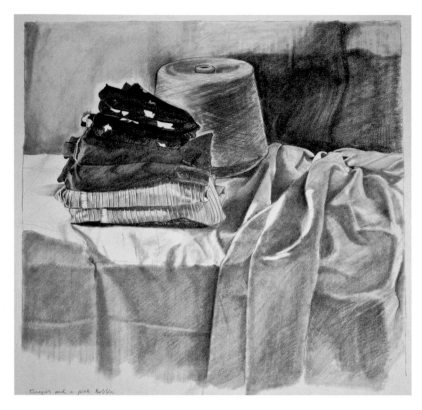

Drapes and pink bobbin, graphite, red and black chalk on Johanoff paper, 38 x 58 cm (15 x 23 in.).

BELOW: Conté sticks and a sketch.

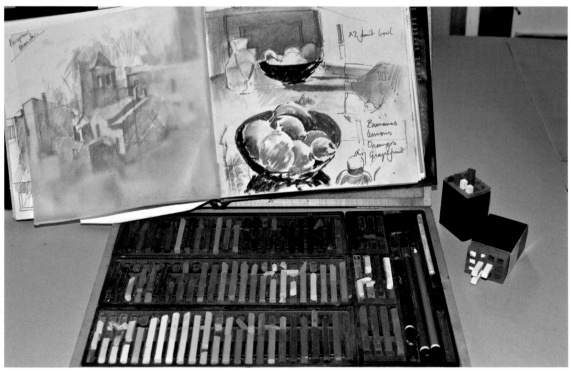

Inks

Inks, too, are one of the oldest drawing materials and have been used for thousands of years. It is thought that high-quality inks were first produced in China by mixing black carbon, charred vine stocks, soot or other natural black carbons with animal-skin glue to make slabs. Once wetted and rubbed, these blocks released a powerful black ink and it was this that the Chinese used to make beautiful drawings, often on silk.

Indian ink – that dense, carbon-black, staining liquid that can give such wonderful results – is more often made with shellac as a binder and, when dry, will form a hard, indissoluble crust, the ruin of many a good fountain pen or Rapidograph. These days you can find good black inks in cartridge form, which do not dry out unless left for months, but it is still a good idea to thoroughly rinse pens and brushes after use.

Some manufacturers use dyes to obtain the brilliant colours of their transparent inks, and these are reasonably permanent, although there is not the same degree of testing of inks as there is of, say, watercolours, so works done in ink should not be exposed to strong light. It's a good idea to test the ink for solubility before using a wash over your drawing: some black inks wash out completely in water. Body colour – a rather misleading term I've always thought – is white or opaque colour used together with a wash in drawings to add depth.

Pens

I like to use an old-fashioned pen-holder and steel nib, as they are very easy to clean and make an incisive mark, but I also like to experiment with different types of pen. Rotring ArtPens are convenient because they take a large-sized ink cartridge; Rotring Rapidographs are excellent for fine work, but the nibs are finer and prone to clog, which is annoying when you want to get on and draw. Ordinary fountain pens are fine, too, either with or without cartridges, but be sure to rinse them well after use. Felt-tip pens are great for bold effects, and the better ones have good strong colours, although we don't know how permanent these are.

For illustrations and smaller drawings, I like the fine black pens that are sold in many art shops, such as Pilot or Uni-Ball to mention just two brands. The very fine ones give a line that is close to what I would get with an etching. I really enjoy drawing with a biro too, although I find that the inks are rarely black enough; my favourites are the cheap Bic biros, which come in several widths of line. Towards the end of his life, Ben Nicholson did a wonderful series of still lifes and landscapes using biro and gouache. The ball point of the pen makes a unique groove in the paper, which can be used for effects of texture.

Near Shotover, pen and ink,
34 x 54 cm (13½ x 21¼ in.).

Ink, a brush and pens.

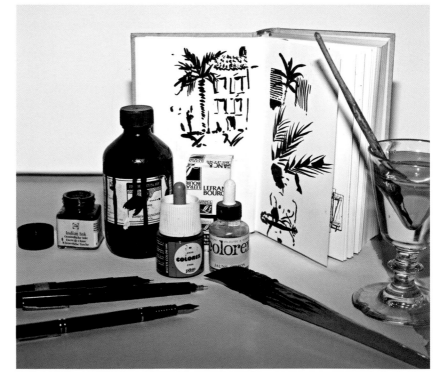

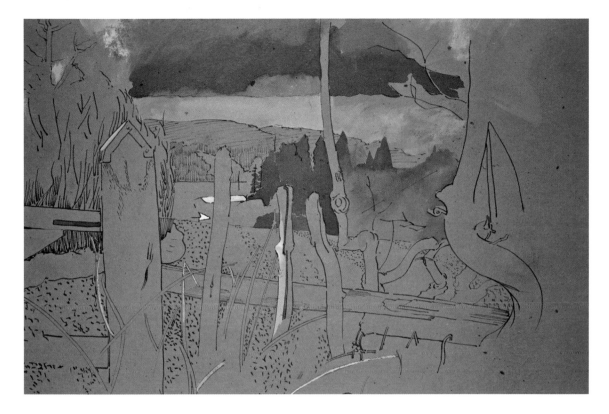

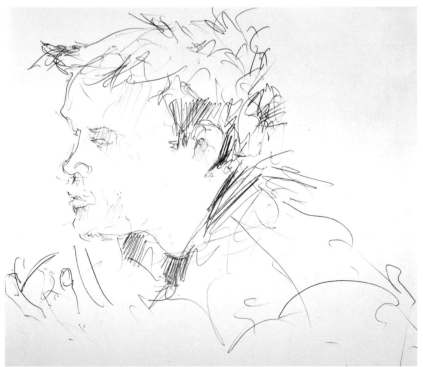

The Gaines, pen and wash,
34 x 54 cm (13½ x 21¼ in.).

LEFT: A biro drawing.

PENCIL DRAWING

Felt pens and crayons.

The pencil, surely one of the most durable of inventions, consists of a graphite core securely held in a wood sheath, apparently first perfected in Italy. They are graded on a scale of hardness, where H means hard; HB hard black; and B black. Artists use all types of pencil, but most often used are the softer ones from 2B to 6B.

Clutch pencils, which open to allow the insertion of a thick pencil lead, are very practical – especially those able to grip the big, soft leads that I use for larger drawings. An important natural deposit of mineral graphite was discovered in Cumberland and some of the best pencils are still made in the area, as well as pure graphite sticks, which can be good for large drawings and broad effects. Buy only good-quality pencils, as cheaper brands can be hard, uneven and scratchy, making drawing unpleasant.

When doing drawing workshops, I discourage the use of rubbers or erasers, as they efface the previous work – which can actually be a guide to getting the line right and can enrich the character of the drawing. The putty rubber, however, is another matter. Used with charcoal this can be an excellent drawing tool: mould it to a point or edge and use it to tease out highlights in a charcoal drawing or, if the paper is covered in an even coat of charcoal, the whole drawing can be executed using the putty rubber to draw light forms by lifting the charcoal off the paper. This is an excellent way of revealing highlights (in a portrait, for example) and, once fixed, the drawing can be continued in charcoal.

Projects

- To help in gaining a better understanding of contrast in composition, make small, vigorous drawings to convey light and shade using a soft, sharp pencil.

- As an aid to tonal composition, use charcoal to obtain a tonal range from deep black to the faintest grey – sky studies at dusk, for example.

- To practise making bold graphic compositions, try drawing things around you using undiluted Indian ink, such as a house facade, a motorway or a chair, with brush or felt tip.

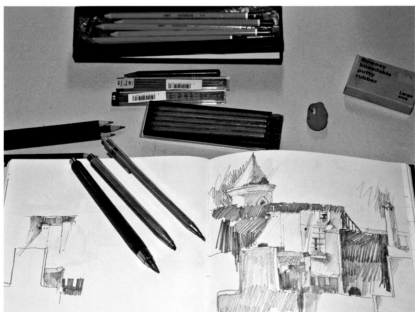

Hulchrath, pencil and white chalk on Johanof paper, 36 x 56 cm (14¼ x 22 in.).

LEFT: Graphite pencils, a putty rubber and sketchbook.

Crayon drawing sketch book.

Coloured pencils

Wax or oil-based colour sticks are also good for certain effects, especially gestural lines, but again it's a good idea to buy the best quality if you want your drawings to last. Buy the harder type as these will give a purer line than the soft sticks, which tend to crumble on the page.

Coloured pencils are really a kind of hard pastel, and most of the major art companies make them. One of the oldest manufacturers is Cumberland Graphics and I have used their coloured pencils with pleasure for many years. More recently, the water-soluble coloured pencil has become popular, because the colour can either be mixed on the paper or the pencil itself dipped into water to produce a thick, coloured line. On a small scale, these are very effective when used on paper that has been lightly dampened with a sponge. Take care when sharpening these pencils, as they are often very soft and break easily in a pencil sharpener. I have found that using a sharp cutter to carefully shape the tip is the best way to obtain a point and to avoid breaking the lead.

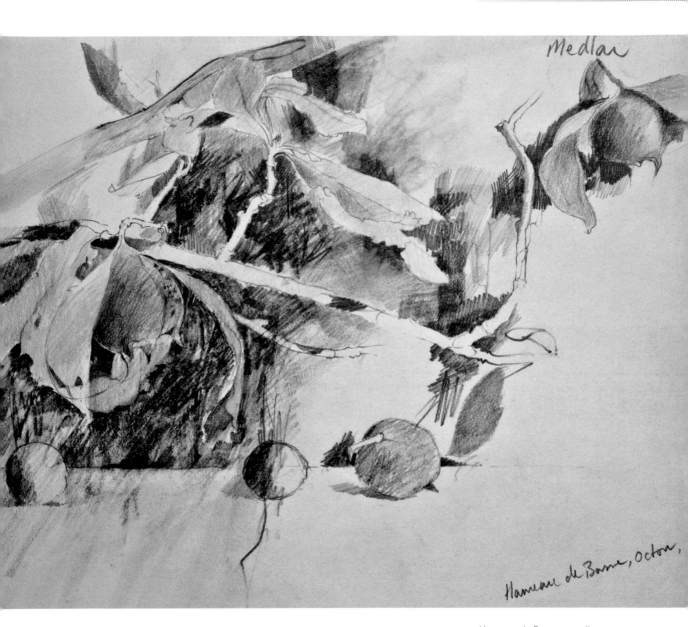

Hameau de Basse, pencil,
chalk and crayon on
200 gsm cartridge paper,
36 x 56 cm (14¼ x 22 in.).

9
SUPPORTS FOR PAINTING

PREPARING CANVAS

It is very nice to buy a ready-stretched canvas complete with wedges to tighten the canvas, but this can be expensive and sometimes the prepared surface of a canvas is not what the painter wants. Usually, ready-prepared canvas has been primed with an acrylic ground that will take a variety of media, but these are often rather plastic and without character.

Traditionally, the preparation of a canvas begins with the stretching of the raw material on a wooden stretcher. Canvas is available in many different types, each with a distinct 'tooth' or weave that offers a particular surface. You must decide which one is most suitable for your work. If you are not sure which surface to use, make up several test pieces of different canvases. I usually do this by tacking or stapling the different pieces of canvas to plywood struts 1 cm (½ in.) thick and then priming and putting a ground on each one. The most common canvas, and the most expensive, is linen, which is made from

Canvas stretcher and wedges.

jute or flax. This has a lovely natural umber tone which is pleasant to work on, but almost any fabric can be painted on. (I remember as an art student using old sacks cut up, stretched and primed for portraits: I achieved some rugged effects!) In the 1960s and 1970s, cotton duck was very popular. This is a type of sailcloth, which is a pale, creamy white and very satisfying to use with liquid acrylics. However, unprimed fabric yellows with age and most of the works from that era have lost their pristine quality because of this.

Often, canvas or fabric to be used for painting is creased: if so, it's a good idea to press the dampened fabric with a medium-hot iron just before beginning work on it.

How to stretch canvas

Buy the best stretcher that you can afford. Ideally, you should have wedges to tighten the canvas if it becomes slack during work. Some painters always work to a standard size on a good-quality stretcher and then transfer the finished work to a cheaper one.

Cut the canvas to size, making it about 5 cm (2 in.) larger than the stretcher on all four sides. Tack or staple the canvas around the stretcher using tin tacks or a staple gun (a gun is quicker and easier). I usually begin in the middle of each bar of the stretcher, stretching the canvas tight as I go with canvas pliers, working from side to side until I have a staple or tack at intervals of roughly 5 cm (2 in.).

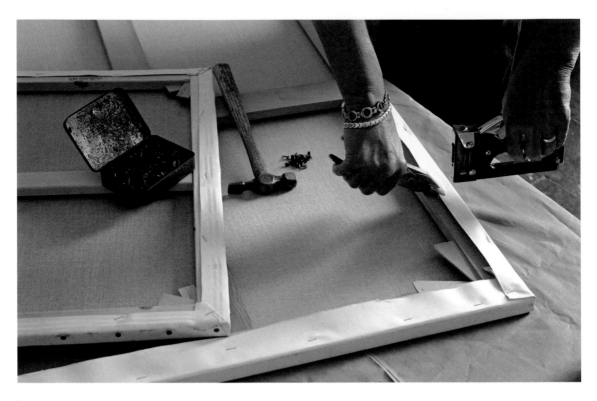

Stapling canvas to stretcher.

Tuck the corners under and staple to finish. I normally fix the canvas on the back of the stretcher, rather than around its edge as is normal practice.

Once the canvas is on the stretcher the wedges can be tapped gently into their slots to tighten the canvas. They should not at this point be driven in too far as priming and grounding the canvas can cause it to stretch. Only when the canvas is ready to be worked on should the wedges be tapped in sufficiently to eliminate creases in the fabric. Never store canvases stretched with staples in damp conditions, as staples rust quite quickly.

Priming

Once the canvas is securely fixed to the stretcher, it can be primed. This is perhaps the most important process for the permanence of the work, because if it is botched, the oils in the paint will penetrate the primer and rot the fabric.

Where I live in France, a complex technique for making grounds – the preparatory coat applied to the support before painting – is often called 'la cuisine' – and this is a revealing term. As someone who loves to cook, I find the preparation of a ground for a canvas, or, equally, the grinding of a special pigment, or the making of pastel sticks, is very similar to cooking and requires the same attention to ingredients, weights and quantities. Indeed, the first time

I ever came across a bain-marie (those lovely double saucepans used by all good cooks to make sauces) was in a painter's studio. It was half full of rabbit-skin glue, a grey jelly that quivered slightly when I touched the pot but which melted to a savoury-smelling liquid when heated.

Rabbit-skin glue or bone glue are the traditional materials for priming. Prepare it in a glue pot in the proportions of about 1:12 glue to water by weight and warm it until it is thoroughly dissolved; never let it boil. You can buy the glue as crystals or as a sheet, but only mix up the amount you need, as the glue does not keep for long. Apply two coats of this to protect the canvas.

Polymer glues, often sold as white wood glues, are a modern alternative. These are very good and much less work, since they are put directly on the stretched canvas without any prior preparation except for slightly diluting them with water. If using polymer glue, apply two or three coats.

Some painters prefer to prime the canvas when it is laid out flat before stretching it, as the glues can penetrate the weave and stick to the wooden stretcher. Once dry, fix the canvas to the stretcher as above.

ADDING A GROUND

Now the canvas is ready to be painted on, or alternatively given a ground – this will further protect the canvas and provide texture and character for the work. There are infinite recipes for grounds, but remember that whichever one you choose, canvas is flexible and will sometimes need to be rolled for transportation (always with the painting outwards); therefore old-fashioned chalk grounds that use animal glue, chalk, oils and pigment are best avoided as they can crack.

Note: Priming a canvas or other support gives an impermeable surface but does not much alter the colour of the support.

Tip

Gesso grounds can be white or coloured. If you want a smoother surface the ground, be it traditional or acrylic gesso, it can be rubbed down with fine sandpaper between coats.

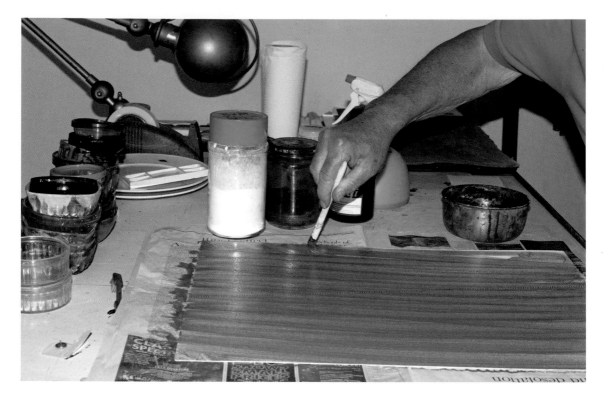

Laying on a grey
imprimatura.

How to make an acrylic ground

You can make a simple acrylic ground by weighing out equal amounts of
polymer glue and pigment. Mix thoroughly and thin with water – it is best
not to put the ground on too thickly, but rather to apply several quite thin
coats. The more glue that is used in a ground, the less absorbent it is. Use white
pigment or colour depending on what you want, but I have found that earth
colours have the best 'key'. (If you are in a hurry to paint and have bought a
ready-to-go canvas on a stretcher, a pigment/polymer glue mix thinned and
brushed on the canvas can give you a coloured ground ready to paint on in an
hour if left in a warm room – put it on thinly with plenty of glue in the mix.)

How to make a traditional ground

To make a traditional non-absorbent ground, weigh out equal amounts of
rabbit-skin glue, sun-dried linseed oil and pigment. Mix the oil and pigment
well and then add the glue drop by drop until a creamy consistency is obtained.
If the mixture is too stiff, add more glue. Brush several coats of this mixture
on to the canvas, allowing it to dry between coats and then rubbing it down
with sandpaper to give a smooth finish. It can be delightful to paint on such a
ground, but it is time-consuming to prepare.

Notes about grounds

Some painters like to put down their first work in a very liquid form on a fairly absorbent ground, thus sealing the canvas for subsequent coats, but if you paint *alla prima*, directly and in one coat, then you need a non-absorbent ground.

For tempera and acrylic paints, the same basic rules apply, but remember that acrylic or water-based paints should never be used on any ground containing oil; oil paints, however, can be safely used on a polymer acrylic ground.

PAINTING ON PANELS

Paintings on boards or panels have a very long history; some of the earliest oil paintings were painted on cradled panels and are still in very good condition. One reason for this is that the support is very stable and doesn't move much, unlike canvas, and thus the older types of ground such as gesso can be safely used. A well-made gesso (or chalk) ground and the modern polymer equivalent are quite different. Real gesso was developed for gilding and was usually laid onto wood and sanded before the gilding process. Acrylic gesso is a similar product but because of the low chalk content and acrylic (flexible), binder, it is suitable for use on canvas. Making a gesso ground is a long process and needs to be done with care and patience.

Cradled panel.

Traditionally, a panel is made of oak, and the cradle of jointed hardwood. The panel is pinned and glued to the cradle and the pins driven well in to the wood so that the pinholes can be filled before the ground is applied.

How to make a gesso ground

For a classic gesso, weigh out equal amounts of rabbit-skin glue, sifted whiting (ground chalk) and titanium white pigment. When well made, this provides a beautiful, porcelain-white surface on which to paint. Because gesso is absorbent, artists in the past would often begin a painting with thin coats of tempera, which provided a composition or *imprimatura* and also sealed the gesso so that oil paint would not penetrate the ground.

Nowadays, few of us have the time or money to buy and prepare the mature woods that were chosen for cradled panels, but well-seasoned plywood is a good alternative, especially when fixed to a frame. Sand it and seal it with either polymer glue or rabbit-skin glue. Apply the gesso with a spatula, as this will fill the grain of the wood better than a brush.

Applying gesso to canvas.

A gesso ground does not have to be white – use any colour of pigment. Earth pigments (see pp.18–26) have a better key than synthetic pigments. Alternatively, after the last coat of gesso has dried, lay on a thin wash of colour.

How to make an acrylic ground

One of the problems with painting on boards, either hardwood or plywood, is that the grain shows through a thin ground and can be a distraction. The following ground can be brushed on boards that have been given a coat or two of rabbit-skin glue or polymer glue and lightly sanded.

Mix equal quantities by weight of polymer glue and plaster of Paris in a clean bowl. Add pigment to give the desired colour, and thin with water until you have a workable consistency. Apply immediately. On drying, this ground will fill cracks and wood grain. Sand lightly before applying another coat. For a smooth, non-absorbent ground suitable for oil or acrylic paint, add a final coat of slightly thinned polymer glue. (It's a good idea to apply a thin coat of ground to the back of the panel with each coat, as this will prevent the wood from warping. Sand lightly to finish.)

OTHER SURFACES FOR PANELS

Some painters like to stretch canvas over a plywood panel and paint on the prepared surface, whereas others favour a 'marouflage' – paper glued down on a board or canvas and prepared with a ground.

For the first technique, lightly dampen the canvas (or fabric) before applying it to the plywood, turning it over the edges of the board and nailing or stapling it to the back. When it is dry (and the canvas should by now be stretched tightly over the surface), apply a primer and a ground as above. Use a heavy plywood, as a thinner panel will bend under the pressure of the tight fabric.

For marouflage, cover the back of the paper in glue (polymer glue is good for this) and then press it on to the board or stretched canvas. It's a good idea to cut the paper slightly larger than the support and then trim it when it is dry. Leave to dry for several days. The paper does not have to be weighed down while drying.

Tip

Don't forget that a support is your means of getting the best from your ability as a painter – if, despite experimenting with a particular ground, you find it unsympathetic or irritating, change it!

Projects

Experiment with panels and grounds to learn more about which ones you prefer.

- Cut three small pieces of canvas, stretch them over three pieces of plywood and prime them. Put a different ground on each: gesso ground, acrylic ground and marouflage.

- Don't forget to make a note of the ground on the back of each board. Try working on each ground to see which one you prefer.

10
PAPERS

Paper was probably invented in China around 2,000 years ago. It is made of pulped fibres such as those from wood, cotton or flax. The word 'paper' is derived from 'papyrus', a plant that grows abundantly along the River Nile in Egypt and was used to make a kind of coarse paper. The most basic component of an artist's materials, paper is a vast subject, but there are several guidelines that should be followed by the serious artist. It's a good idea to try plenty of different papers until you find one that you like. Spend as much as you can afford on paper, as cheaper paper can be disappointing for fine work. I have taken great pleasure in fine papers and I know that I do better work if the paper is of good quality.

HANDMADE PAPER

Early papers were handmade and this is generally still the best type of paper, although it is more expensive than machine-made paper. The best handmade papers are made from washed cotton linters, which are the short fibres that come from cotton plants or, more commonly, from recycled linen, cotton sheets or shirts etc. The linters are washed and pulped into a mush, sometimes with a glue added, and this is then agitated in a sieve or mould (sometimes called the deckle) before being turned out on to a blanket. The sheet is then pressed until it is dry. Many papers incorporate a watermark or the maker's name, which enables us to identify the paper.

The more glue – or size as it is often called – that is added to the mixture, the harder and less absorbent the paper becomes. Some papers are surface-sized in addition: this is sometimes called tub sizing, after the tub of liquid glue into which the dry sheet is dipped before being dried for a second time.

Paper moulds are normally rectangular frames with a fine wire mesh attached to the lower side, rather like a very fine sieve. The pulp is spread in it and excess liquid drains through the mesh before the sheet is turned out on to a drying blanket. The sheet will have four rough edges or deckles, which is one way of telling whether a sheet of paper is handmade. Acidity – either in the water,

Saunders Waterford 600 gsm paper. A very heavy, machine-made watercolour paper. Also suitable, when primed with an acrylic ground, for oil painting, acrylics or pastels, as is the whole range of Saunders papers.

Barcham Green Cotman. A rare and expensive handmade watercolour paper similar to papers used by Turner and made at the now defunct Hale Mill. Sometimes to be found for sale on the Internet.

Indian handmade paper. Like all heavy papers, this is suitable for watercolour and, when primed, for oils, acrylics and pastels.

Amalfi handmade paper. A sensitive and beautiful paper for watercolour and drawing.

Richard de Bas French handmade paper. A fine paper for drawing, pastels or oils.

Hahnemühle 300 gsm 'not' paper. A beautiful paper for watercolour and drawing.

Indian rough. A rugged paper suitable for all media.

Jackson's HD handmade. A very hard-sized watercolour paper, also suitable for oils and pastels when primed.

Buff wove handmade paper. Tinted papers are good for pastels, gouache or oils when primed. Many watercolourists use such papers, adding white body colour to their colours.

water, linters or glue used – causes paper to yellow with age, and this is why paper mills have always traditionally been situated by a pure water source. The cheapest handmade papers usually come from India or Asia and can be good, but probably the finest are made in France, Germany and Italy. Sadly, little handmade paper is produced in England these days, although of what is, some is excellent.

MACHINE-MADE PAPER

The Industrial Revolution saw the establishment of large, well-organised paper mills, which provided papers chiefly for printing. In Britain three different surfaces were common:

- *Hot*, or hot-pressed paper (sometimes labelled as smooth) is run through heated steel rollers to give it a smooth, slightly shiny surface.

- *Not* (sometimes called fine-grain paper) is pressed between cold rollers to give a medium finish.

- *Rough* paper is simply dried between felt blankets: the rougher the blanket, the rougher the resulting paper.

Fine papers such as bond, for documents and fine printing, are light weight and hard-sized for toughness; papers for drawing and painting are usually heavier.

Modern production

Today, machine-made papers for artists are made on circular drums in long lengths, and then cut to the required dimensions. The composition of the best of these is very similar to that of handmade paper.

Interestingly, when we buy paper today, the most commonly available size is 56 x 76 cm (22 x 30 in.), which is the old French paper format called Jesus. All the quaint old English names such as Double Elephant, Pott and Super Royal seem to have disappeared. Blocks are available in various sizes but do not seem to follow international paper standard (ISO) sizes (that is, from A0 to A6). The unit of grams per square metre, gsm, is used as a unit of measure for weight.

Machine-made paper differs from handmade in its surface texture, as the machine process does not allow for the unique quality of each sheet found in handmade papers. Nevertheless, the best machine-made watercolour and drawing papers are very good for artwork. Some mills are even returning to the use of linen rags in order to make the paper more sympathetic to watercolour – cotton rag papers do not 'wash out' well. In watercolour technique if a colour is too harsh or strong we sometimes apply water carefully to the work with a sponge ('washing out').

In older linen papers it is far easier to dilute or wash out the colour – modern cotton rag papers tend to break up if the wash out is too vigorous.

Recommended papers

For many years now I have used Saunders Waterford papers, made by St Cuthbert's Mill in the south-west of England; I also like the French papers, Arches and Lana, and the German papers produced by Hahnemühle and Schoellershammer. I used to paint often and with pleasure on Italian Fabriano paper, but recently the firm has changed the texture and glues and for my work it is less sympathetic than the older papers, with their fine texture and drying characteristics. I am often asked to test new papers: companies are constantly trying to anticipate the market in leisure art, which is huge nowadays; some new papers are good but usually changes come at a price.

Years ago, when watercolour papers were made for a relatively small market, the ingredients changed little and you could depend on the paper retaining the same character. However, the enormous growth in popularity of watercolour painting, coupled with a strange aversion to the traditional animal glues that are so much a part of good watercolour paper, has seen a fall in quality of some papers – cheaper ones are made using a type of wood pulp that can yellow in strong light, and some of the new synthetic glues used make subtle washes and graded colours all but impossible. The yellowing of paper can be a big problem. Exposed to pollution, smog or smoke, airborne chemicals and so on, papers and textiles will yellow, some more than others. Works on paper should be framed under glass and the paper should always be 100 per cent cotton.

The papers discussed in the following pages are readily available, but I am constantly trying new papers to test for new effects and it is essential for the evolution of a painter's work that we try new materials.

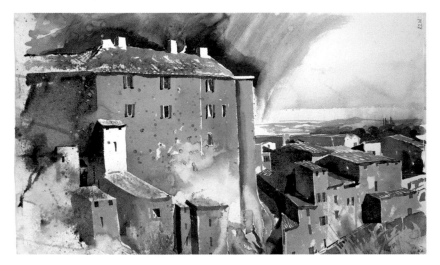

Village Remains (detail), watercolour on Indian handmade paper, 56 x 76cm (22 x 30 in.).

PREPARING PAPER

The preparation of paper for drawing and painting is an important ingredient in the appearance of the final work. Firstly, you want to ensure that the paper remains flat. For example, light papers that are not stretched will cockle when painted on with water-based paints, and the best way to flatten them is to stretch the paper when the work is complete. Even a quite heavy paper will cockle if much water is used, but if stretched on a board it will flatten on drying.

STRETCHING PAPER

Lightly wet the back of the papers with a damp sponge.

Turn the paper dry side up and using pre cut lengths of dampened white gumstrip glue down each side.

Use your fingers or a soft cloth to press the wet gumstrip down onto the board.

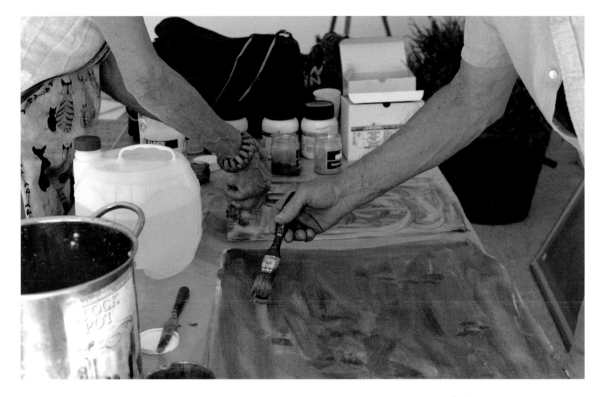

Putting a ground on paper.

Certain papers, no matter how expensive, can prove unsuitable for your work – you will find that either they are not absorbent enough because of hard-sizing, or sometimes they behave like blotting paper because there is no surface size. You can sometimes improve paper that is very hard-sized by sponging the surface with water or soaking it for a short time in a water bath. Papers with too little size can be surface-sized using a gelatine solution of 20 per cent gelatine to 80 per cent water, brushed on both sides of the paper. Make a note of how you have prepared the paper in pencil on the paper's edge.

Fine paper

For fine papers, such as Ingres paper, it is a good idea to use the old technique of stretching the paper using egg white. You will need a smooth board, such as hardboard on a wood frame, melamine or formica-coated board. Coat one side of the sheet with a fine film of egg white. Press the paper onto the board, coated-side down, so the egg white adheres to the surface. Smooth the sheet from the centre towards the sides using the palms of your hands or a soft, felt-covered bar of wood. If this is done correctly, the sheet will dry absolutely flat and can be painted almost to saturation without cockling. Once dry, simply peel it off the board and press it lightly.

MAROUFLAGE WITH EGG WHITE

Painting the back of the paper with egg white.

Pressing the paper on to the board.

The paper flat when dry. Note that the test paper in front of the photo has cockled, because it wasn't stretched.

Heavy paper

A heavy handmade paper, such as that produced by the French company, Moulin de Larroque, can be painted on with no preparation. A typical machine-made 300 gsm watercolour paper can be stretched on a board, the edges secured with gum strip. I prefer not to wet the working side of the sheet, as this can alter the quality of the paper, so I turn it over, lightly dampen the back and then fix it to the board, damp-side down, using white gum strip (brown gum strip is acid and should never be used for this) along all four edges. This method is also good for papers used for acrylics, oils or collage.

Watercolour papers are also available in blocks of various sizes, with the paper held fast by glue on each side, so it needs no preparation. When a work is finished, cut the sheet from the block to reveal another beneath it by inserting a thin knife blade under the sheet at one corner and running the blade around the block.

Many painters use paper as a support for oil and acrylic painting, and if the paper is properly prepared it can last as long as canvas. Prepare the paper by gluing it to a varnished board and giving it a coat or two of primer before using it to paint on (see pp.84–5). Heavier papers are best for this; but a really heavy paper, for example 600 gsm, need not be glued to a board. For oil painting on any paper, a coat of primer is essential.

DRAWING PAPERS

For drawing, good cartridge paper (so called because it was used in ordnance) is easily obtainable in different weights and surfaces, and conforms to the same rules as watercolour paper with regard to weight and materials. Some drawing papers are coated with kaolin to give them extra smoothness – glossy brochures often favour this kind of paper – and these are good for crayon or oil pastel work. You can get drawing papers in almost any colour imaginable, the most well-known perhaps being Canson, the French paper sold in almost all art stores. One side of Canson paper has a rather uniform machined surface, which can be unsympathetic, but I simply use the other side, which is smoother and good for hard pastel and chalk.

POPULAR PAPERS FOR WATERCOLOUR AND DRAWING

Machine made papers

All of the papers listed below are available in a variety of sizes, weights and surfaces. Try different papers to find your preference.

Arches An old French paper, and very good it is too! Available as blocks, rolls or sheets, in a choice of three surfaces. 300 gsm. Tub sized. These papers are made using animal glues and smell when wetted. Somewhat hard surfaces. 100% cotton rag, acid-free, neutral pH.

Bockingford A Wookey Hole Mill paper, these have either a pale cool tint or a warm cream shade, ideal for gouache or watercolour and body colour. Also available in white.

Canson papers A famous firm that is now part of a multi-national company, Canson papers can be very good. Personally, I don't like their watercolour papers except for occasional wash drawings, but the drawing papers are good and they are available in a wide range of colours. I prefer the smooth side of these papers to the rough, rather uniform side often seen as a support for pastel.

Fabriano Fabriano is a village in Italy that has been making papers for generations. I find their watercolour paper, recently changed from the old Artistico, a lightly laid, 300 gsm paper, is not so good but certainly worth a try. They make a big range of papers, including very good drawing paper. The 600gm Satinata used to be favoured by the Austrian watercolour school but like most of their papers I am told by painters who have used this paper that the change to a different size glue has rendered the paper unfavourable. (See p.100.)

Fontenay Good French papers for studies.

Hahnemuhle (Moulin du Coq) A German paper available in many different qualities; their watercolour paper, is one of my favourites (although not the rough surface, which is unsympathetic). It is very white. 300 gsm. 100% cotton rag, acid-free, neutral pH.

Ingres paper Ingres is a generic name for light (150 gsm and less), laid papers. A laid paper has fine parallel lines visible on the surface. It is good for drawing and painting if glued to boards.

Radial 1, mixed media on handmade 400 gsm paper on board, 38 x 38 cm (15 x 15 in.).

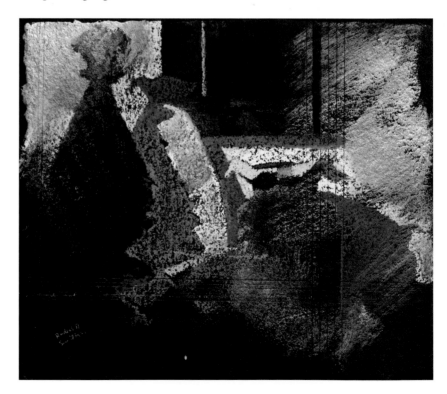

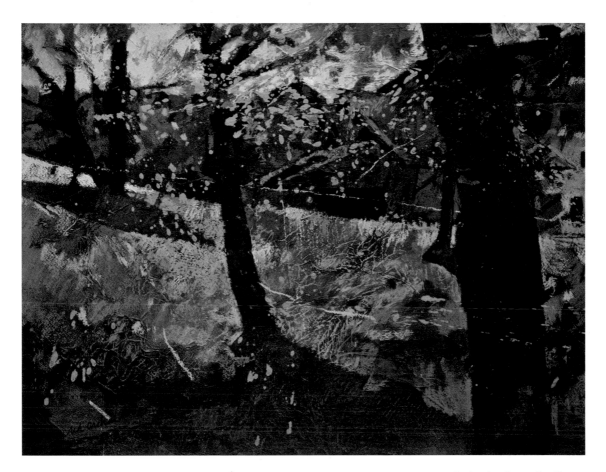

Johanof A soft French paper good for drawing. Used to be available but now difficult to obtain.

Lana A French paper, these mills have been making good paper for many years, and, indeed, make some of Winsor & Newton's watercolour papers. Paper is available as blocks or sheets, and in a choice of three surfaces. 300 gsm. Tub sized. 100% cotton rag, acid-free, neutral pH.

Montval French watercolour and drawing papers that will take some washing out, such as these, are a rare quality these days. They are available as blocks or sheets in one surface. Acid-free, neutral pH, 300 gsm. Montval paper is one of the papers favoured by G. Salzmann, the Austrian watercolourist.

Rives A French printing paper that is also very good for drawing.

Saunders Waterford Made at the old paper mills at Wookey Hole in the west of England, Saunders Waterford papers are available in several weights and sizes, and have been the first choice of many painters for a long time. Surfaces include hot pressed, not and rough. Off white or super white. Tub sized. 100% cotton rag (no cellulose), acid-free, neutral pH. (See p.101.)

Red orchard, pastel, collage and acrylic on 300 gsm handmade paper, 40 x 60 cm (15¾ x 23½ in.).

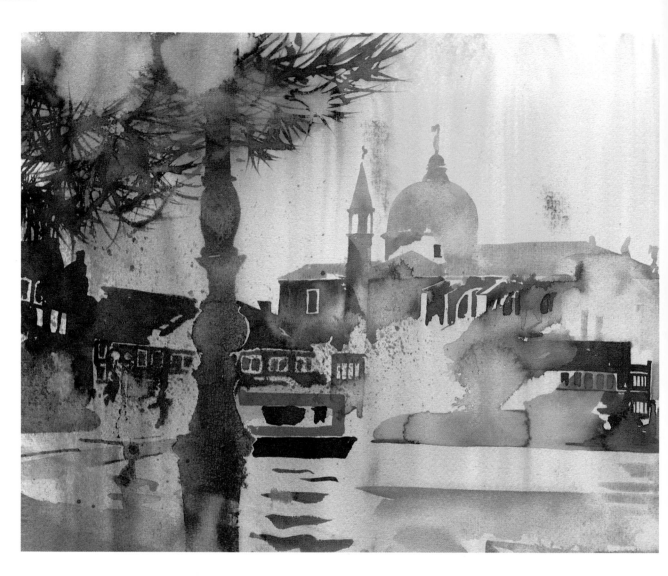

Giudecca, watercolour on Fabriano Artistico 300 gsm paper, 36 x 56 cm (14¼ x 22 in.). It is very sad when a favourite paper becomes unavailable. Fabriano stopped making this beautiful, rather difficult paper according to their usual formula in around 2007. They changed the glues and the surface, making it unrecognisable and more like some of the readily available cotton papers that are so ubiquitous in the market now. The old paper took watercolour in a unique way. It's a great shame.

RIGHT: *Old Boat Dock*, watercolour on Saunders Waterford 180 gsm rough paper, 36 x 56 cm (14¼ x 22 in.). One of my favourite papers, which is particularly good for effects of granulation. Note the way that the paper has taken the colour in the upper half.

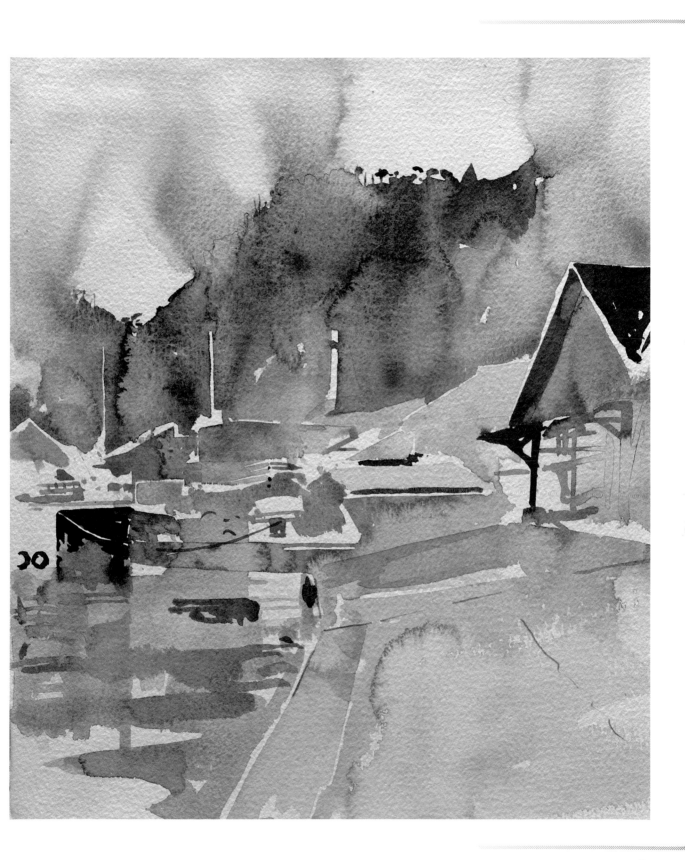

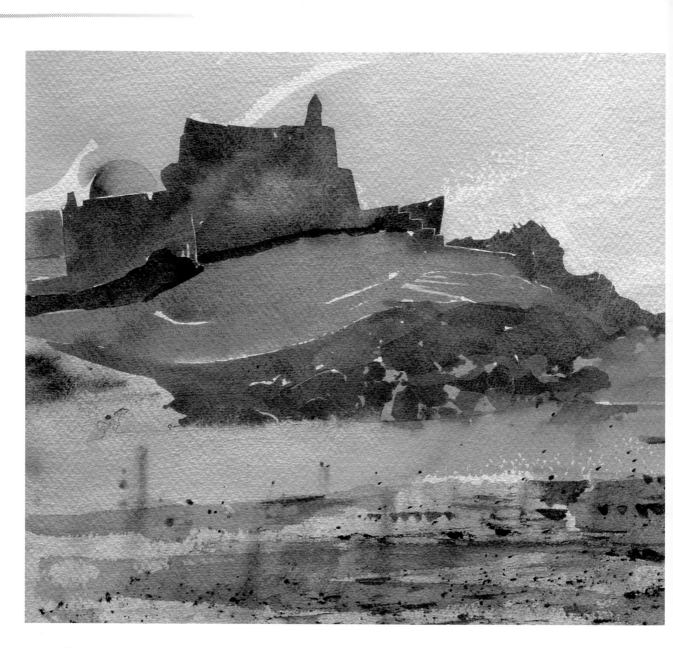

Sidi Jemour, watercolour on Amatruda 250 gsm handmade paper, 36 x 56 cm (14¼ x 22 in.). I love this paper as it takes colour so well, allowing passages of pure unbroken colour. Made in Italy at Amalfi.

RIGHT: *Kyoto Temples*, watercolour on Moulin de Larroque handmade 400 gsm paper, 56 x 36 cm (22 x 14¼ in.). A wonderful paper that I have used for over 30 years. Notice the way that the paper holds the colour.

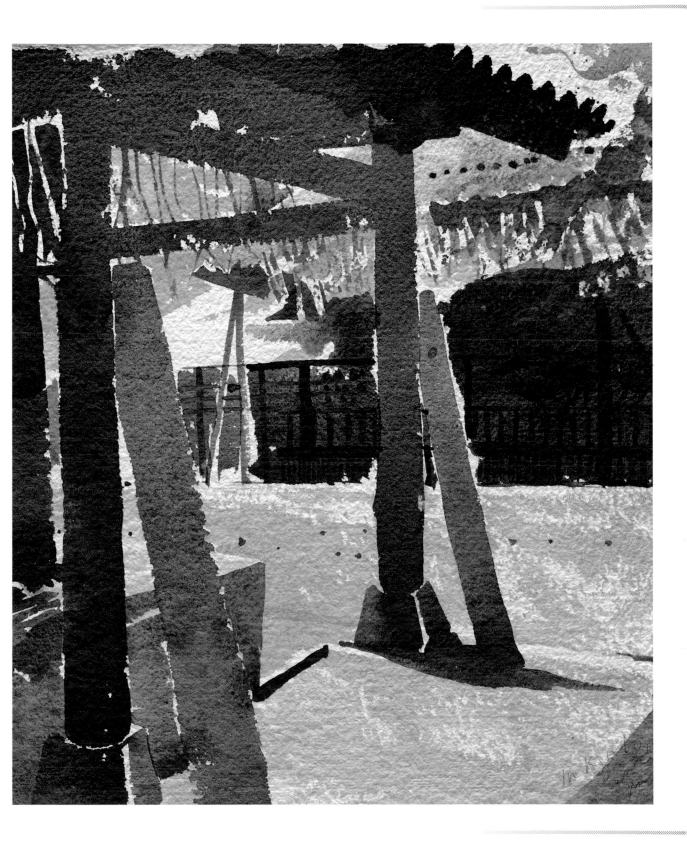

Schoelleshammer German papers that are very good for watercolour and drawing.

Somerset Very good drawing and printing papers, available in England.

Zanders treff Excellent German drawing paper available in various weights. Zanders was recently taken over and now makes coated papers, but just because a paper is no longer made it does not mean that it doesn't exist! Old stocks of 19th century papers can still be bought at auction and Zanders drawings papers can sometimes still be found.

Zerkal Papers German-made watercolour and drawing papers, these are fine products.

Some handmade papers

There are hundreds of small paper mills all over the world producing fine, and not so fine, papers. I have tried many of them and they are always interesting, but the following were available at the time of writing and usually it is easier to order these direct from the mills when possible. They are 100% cotton or linen rag, acid-free, available in a variety of weights, sizes and surfaces.

Amatruda, Amalfi, Italy Superb but expensive watercolour, drawing and printing papers. (See p.102.)

Moulin de Larroque, Couze, France Beautiful papers at good prices. (See p.103.)

Two Rivers Paper Company, Watchet, Somerset Some fine papers at good prices. Very hard sized, which is good for some techniques but will not suit everyone.

Khadi papers, Chichester, England Made in south India, these papers are made to a good specification and are inexpensive. They are acid-free and available in several weights.

Project

- Using one watercolour (ultramarine or burnt umber), try brushing marks into small samples of various different papers to create a wide variety of marks. Compare these when dry to learn the differences between the papers and their various possibilities.

11
WORKING OUT OF DOORS

Working out of doors, or *en plein air*, requires special equipment and techniques. There are many accessories on sale, such as easels, paintboxes and stools, but bear in mind that everything should be easily portable: getting on and off buses or trains or in and out of cars with a large, heavy case is inconvenient, even if you can pull it behind you on wheels.

EQUIPMENT

Easel

Perhaps the best-known item for working *en plein air* is the folding box with retractable legs, a lid that doubles as an easel when fixed in the open position, and various drawers or compartments for storing paints, brushes and supports. It is also known as a pochade box.

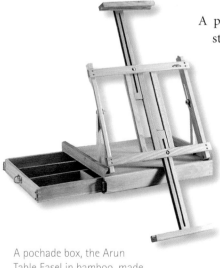

A pochade box, the Arun Table Easel in bamboo, made by Winsor & Newton.

A pochade box is fine for sketching, but large paintings require a stronger, more stable support and it is quite difficult to find easels that are light and portable with good stability. The small metal ones sold in nearly all art shops do not give sufficient stability for boards or canvases larger than 30 x 50 cm (12 x 19¾ in.), even in calm conditions; the larger wooden easels, though better, are heavy and cumbersome to transport.

The illustration on the next page shows a simple design which, with a heavy stone or other weight hanging between the three legs and attached to the top of the canvas or board, gives great stability. Vincent Van Gogh used pegs driven into the ground and fixed to the bottom of each leg of the easel to paint in the mistral winds of the South of France, with a screw eye in the back of the canvas tied to the easel to prevent it blowing away. Of course, if you have access to a car large enough to carry a studio

easel, these are great for outdoor work. Boards for painting and drawing should be strong enough not to bend or break, but not so heavy as to be an encumbrance; mine are usually of light plywood.

Students of painting often only consider a portable stool as an afterthought, but this is a mistake. Nothing can spoil the enjoyment of a day painting outdoors more than an uncomfortable stool. It should be the right height – too high and you can't reach to the ground to pick up a brush or tube; too low and you may get cramp.

Working in watercolour

Watercolour paintboxes are tough, compact and portable and can hold pans or tubes. I manage to transport all my watercolour materials in a strong shoulder bag, but bear in mind, when planning your outdoor kit, that watercolour boxes need to be packed flat otherwise the paint that is wet after use will flow out and be spoiled. Also in the bag are water containers, spare tubes and pans of colour, brushes in a bamboo roll, crayons, pencils and sketchbooks. Together with the folio, they constitute a complete outdoor painting kit that is not too heavy to walk around with.

ABOVE: A field easel.

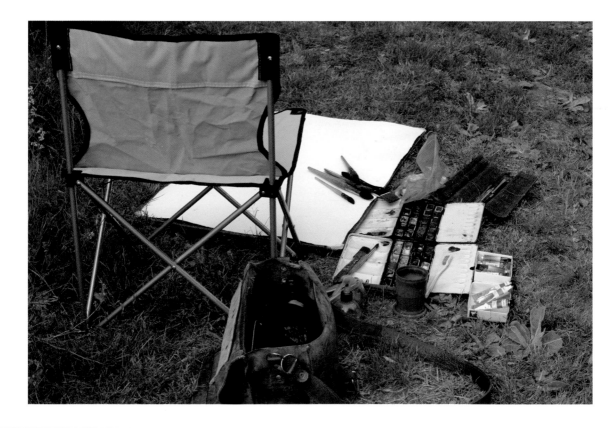

If you are using tubes of paint, a plastic palette with recesses for paint and larger areas for mixing is useful, but if there is a large amount of paint left when you are packing up, the palette must be packed flat to prevent this running out.

Usually, watercolours are painted flat so that washes stay on the paper, and some painters like a lightweight folding table to work on. Others prefer a camera tripod with a special attachment underneath for the board, so that the watercolour can be painted in a standing position.

Working in pastels

For pastel work out of doors, a portfolio and board are essential. The portfolio will take papers or card for the pastel work and the board too. Once the pastel is finished for the day, it is turned face to the board and taped in place so that the work is not damaged in transit. Artists' pastel sticks are fragile and need to be packed in foam, or at least a wooden box with kitchen paper, to absorb shocks. Your bag should be large enough to hold pastel boxes, fixative and clips or tape to hold the paper to the board.

A large watercolour box made by Blockx, a smaller one with Kremer watercolour paints and various tubes of watercolours.

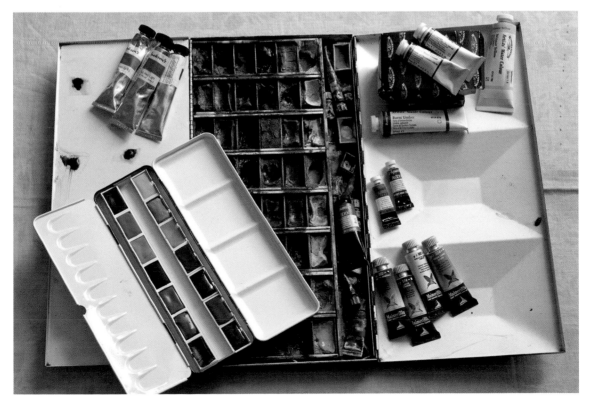

ABOVE: Working outside.

FACING PAGE: Pastel outdoors.

Extra kit

Sketchbooks are always a good thing to have with you. Sometimes there can be more information in a drawing or a series of sketches than in a finished work that has gone wrong because of bad light, rain or some other interruption. I like landscape-format sketchbooks: Seawhite of Brighton and Daler-Rowney, among others, make very good ones. Some of the most pleasurable moments on painting trips have been as the working day begins, working out a composition in front of the subject with pencil, pen, ink or crayons. For those who work paint into their drawings, a sketchbook with heavy paper is useful.

Also useful for working outside are a polythene bag large enough to hold the board or canvas and protect the work if it rains, anti-mosquito cream, sunblock, a hat that protects the face and eyes from sun and wind, and a small camera to record the scene if the day's work is interrupted.

Transporting artwork

The transportation of canvases with fresh paint can be a problem, but many painters use a system of spacers between two or more canvases of the same size, attached to the edge of the stretcher, to protect the wet paint. There are many different types of carriers for wet canvases on the market.

For watercolour and drawings, the best accessory that I have found is the travelling portfolio, and I have taken one of these with me all over the world.

LEFT: A travelling folio.

RIGHT: Outdoor kit and car.

These are readily available in art shops and vary in quality. My preferred type is a folio of light, tough nylon or other synthetic material that will accommodate a board large enough for a full sheet of watercolour or drawing paper, i.e. 60 x 80 cm (23½ x 31½ in.), ten or more sheets of paper, and a light, portable stool in the front pocket as well as tape, hat and sketchbook. For travel by plane, these have to be checked in and it's a good idea to put a stout belt around the folio before committing it to the mercy of baggage handlers, with a board or card inside the folio to protect the paper from damage.

NOTES ABOUT WORKING OUTSIDE

I have spent many years watching weather patterns, not just because they interest me but because you can often plan how long you have to paint before it rains or the light fails. Light changes fast and I usually give myself an hour or so to draw before I begin to paint (taking a note of the time). Often I return on successive days, always at the same time so that the light is similar, and I consider that there is a very distinct difference between morning and evening light.

I try to work in shade, because sunlight either directly in front of you or on the work itself can be very distracting; many painters work with a parasol attached to their chair for this reason.

FACING PAGE: The same scenes in the morning and afternoon light.

TOP: *Fleurs de sauge*, pastel on French handmade 400gsm paper, 60 x 85 cm (23½ x 33½ in.) (morning light).

BELOW: *In the hot afternoon*, pastel on 400 gsm French handmade paper, 56 x 76 cm (22 x 30 in.) (afternoon light).

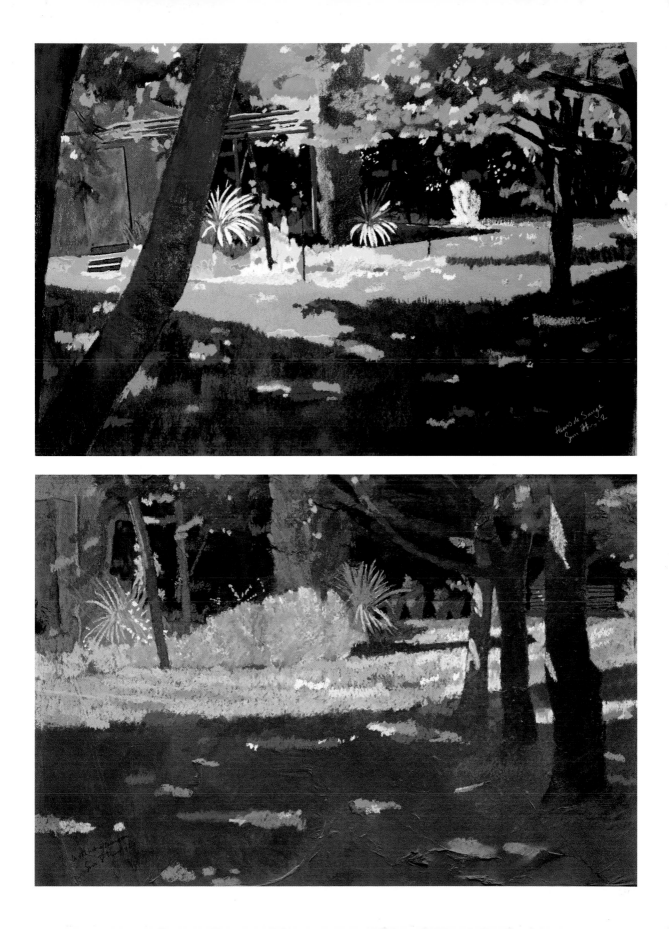

12
STORING AND FRAMING ARTWORKS

STORAGE

For the professional painter, the correct storage of work is an important consideration and the most essential thing is to have dry storage conditions. Damp is the enemy of nearly all supports and will ruin works on paper in a short time, even when stored in plastic bags. Store works in a dry room, such as an attic or storeroom with a minimum of heat. Keep drawings in a plan chest or a cupboard that is free from dust and with a cotton bag containing silica gel, which draws damp to it. Framed works on paper hung for years on damp walls will often show signs of foxing (small brown dots on the mount and paper, which are virtually impossible to remove).

Paper

The choice of material plays an important role in how well a work will last. It should be emphasised that paper that is not acid-free will yellow with age, even when stored in a plan chest or folio. Work on acid-free paper that has been mounted on acid board will show signs of browning in contact with the mount. Exposure to strong light will cause even the best papers to darken and lose their brightness over the years, so it is a good idea to hang works on paper away from direct sunlight. When buying paper, always be sure that there is a description of the product and read the specification carefully.

Don't keep works on paper in large, towering stacks as it can be damaged, but if a series of plywood boards larger than the paper is used between each 10–15 sheets, this will keep the pile of work flat. Separate the plywood from the works using plastic sheet. Factory packs of paper can safely be stored flat if unopened, but avoid making stacks of more than three or four packs.

Portfolios are not ideal for storing work over long periods, but if kept flat and not too full of work they are a good compromise. Works on paper should

LEFT: Paper showing foxing.

RIGHT: Paper will yellow with age unless it is acid-free.

never be left for long periods upright, as they inevitably curl under their own weight. Pastels, prints or delicate drawings should be interleaved with acid-free tissue paper.

Paintings

Paintings on canvas and boards should be stored in racks and never face to face. If they are to be stored for long periods, it's a good idea to wrap them in white acid-free paper and cover with dust sheets, or seal them in plastic bags, but make sure that the plastic does not cause the work to become damp. If paintings have heavy impasto, interleave each painting with a sheet of white paper. If canvases are rolled, always do this with the painted surface outwards, covering the surface with acid-free tissue before rolling, and if possible store the work in cardboard tubes – never roll them in newspaper! Do note: oil paintings should be thoroughly dry before being stored in the above way.

Heat is also dangerous for paintings, particularly if they contain wax. There is a well-known story about a painting that was taken to the owners' Italian villa and hung prominently. On their return from the beach on a hot day, they found that the encaustic wax had melted, depositing most of the painting on the floor! Excessive heat can also cause wooden frames and boards to warp and twist.

FRAMING

Framing is a huge subject and most artists, galleries or dealers will have their own preferences, but there are one or two guidelines that help. The big enemy of paper is acidity and it's for this reason that you should never let any acid paper, newsprint, brown gum strip or cheap pulp paper near an artwork.

STORING AND FRAMING ARTWORKS

Store paintings in racks.

BELOW: Materials for framing.

A selection of frames.

Mounts

Works on paper should always have a mount to keep the paper away from the glass in the frame, which can attract condensation. The mount should be acid-free, and the work attached to the back of it with white gum strip or a proprietary adhesive. It's often a good idea to place acid-free paper between the work and the backboard, which can often be acidic.

Mounting boards are usually either of the Canson board type, often with a slight laid surface (i.e. slightly ridged), or the more expensive museum board, which is often 5 mm (¼ in.) thick and off-white. For watercolours, I prefer a double mount or museum board, and for pastel work I use an even thicker mounting board to keep the pastel dust away from the glass (see illustration of frame on p.117). Beware of using cheap wood pulp card for mounting, as this is one of the most acid of materials: it will quickly cause staining and darkening on white paper.

Tip

I strongly advise inexperienced artists to use professional framers, as amateur efforts always look what they are. It's a good idea to keep a small stock of mounting boards of different tints and sizes to try on a work before taking it to the framer.

Coloured mounts are sometimes effective for monochrome works, etchings or lithographs, less so for strongly coloured paintings, and sometimes a double mount of white next to a print or drawing can bring it life. One of the most common mistakes with framing works on paper is being mean with the mount: mounts should be generous to allow the work to breathe.

Glass

I prefer ordinary glass for works on paper, although museum glass, which filters out UV light that damages art works, is the best and of course very expensive. I never use non-reflective glass, as it mutes colours. Perspex is good for large works, as it is light and strong, but it scratches easily.

Framing works on canvas or board

First decide whether the work to be framed needs varnishing (see also 'Glazing and Varnishing', pp.50–4). Varnish protects oils and acrylics from atmospheric pollution, smoke and smog. It also makes the cleaning of old works much easier because the varnish can usually be removed without damaging the paint layers beneath. Make a note on the back of every work as to which products have been used and the medium used – oil, acrylic or other.

Bottles and pots of varnish, oils, waxes and glazing media.

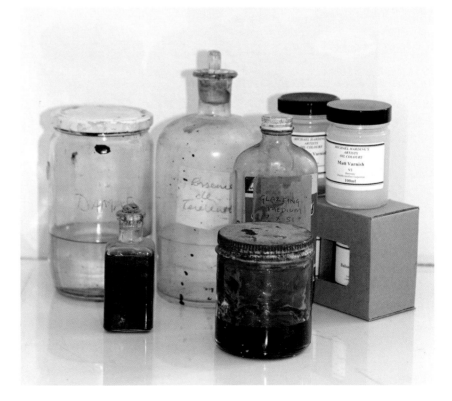

Retouch varnish, usually sold in aerosol cans, is practical because it is available in a matt finish and can be put on thinly. You can also work over it at a later date if necessary. Gloss varnish gives a luxurious feel to dark works, bringing out the colours, but it makes them very difficult to photograph (if you want to record the work, photograph it before varnishing). Dammar varnish is a clear, quick-drying glossy varnish for oil paintings. Acrylic varnish for acrylic paintings is available in either a matt or gloss finish. Never use oil-based varnishes over acrylic paint.

Types of frame

If you own an old painting and want to reframe it, there are specialist auctions where antique and period frames are for sale. Choose the frame carefully, because an injudicious choice can detract from the value of the work.

Frames, like other elements of interior design, follow fashions, so we tend to frame contemporary works according to what is available at the framer's workshop. There are also special plastic boxes that can be used to display works, and modern prints are sometimes mounted on aluminium sheet, which can look very effective but is rather expensive. It's a good idea to take notice of trends in framing and presentation, as frames have become an important part of interior design; often work which deserves attention goes unnoticed because it is not appropriately framed.

When choosing a frame, it should be strong enough to support the work and mount (and glass if this is used) without bending or breaking, and for very large works under glass, a strong, well-made frame is essential.

Mouldings for frames come in all shapes and sizes, but I have often found that the simplest are best. The British Museum, for example, often uses a stock oak moulding for watercolours and prints combined with a deep, off-white mount and I have often used this combination for drawings. Gold frames can look vulgar if they are too large for the painting, but often bring dark works to life; silver frames tend to be cool and good for bright, colourful paintings, and often combine well with modern interiors.

Always remove the hanging hooks or other hardware from the back of the frame when storing work, as they can badly damage the face of other frames or even sometimes leave an indelible mark on glass.

One final thing: just like owners of fine wines, who keep a cellar book, it's a good idea to keep a catalogue of the work that you store, with the name of the artist and a brief description of the work that includes its size, medium, date completed and price paid etc.

Project

• Experiment on a work using three or four different-coloured mounts or frames, to see which one works best.

RIGHT: Getting the frame and mount right makes a difference. The top image is an example of bad framing, the bottom is an example of good framing. (The painting is the same size in both examples.)

13

PHOTOGRAPHING WORK FOR ARCHIVES AND PUBLICATION

The archiving of work is a vital part of the creative process for anyone wishing to keep a record of what they have made, or is planning to publish it in the form of books, magazines or posters. Ideally, archive photography should be done by a professional photographer, but this is an expensive process and below are some notes about doing it yourself.

CAMERAS

SLR cameras

For years I have successfully used a medium-format camera and colour transparencies (6 x 6 cm/2¼ x 2¼ in. or 6 x 4.5 cm/2¼ x 1¾ in.; 35 mm slides are not acceptable to most publishers) to record my paintings for the production of prints and books. Today, many people have changed to digital cameras and traditional medium-format cameras have never been so cheap: a Mamyia 220 or 330 – twin-lens reflex studio cameras with fantastic lenses – can be bought for around £200, the Mamiya reflex 645 for a little more, and a Hasselblad for about £500. With Fuji Velvia daylight film or similar, very sharp, high-resolution pictures can be obtained. Make sure that you know of a processing laboratory that accepts the 120 film used by these cameras (and will convert the transparencies into digital format) before buying one. Many photographic laboratories are converting to digital and often no longer provide analogue photographic processing. There are, however, quite a few laboratories that will scan transparencies on to a CD for a price so if, like me, you are loath to part with the beautiful old technology of medium format, there is still hope.

With the arrival of top-end digital cameras, publishers started asking me to produce high-resolution digital files. This has turned out to be an education. My first important gallery used large-format 12 x 10 cm (5 x 4 in.) colour

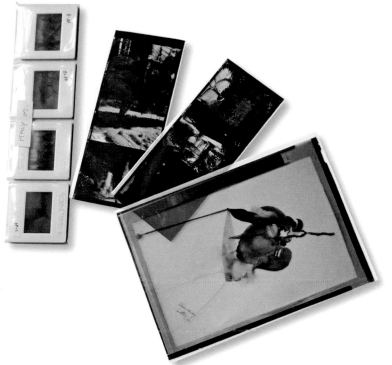

Transparencies and slides.

transparencies, and you need an old-fashioned bellows camera and a photographic plate to do this, as it's 19th-century technology! To get the same sort of high definition with a digital camera, it needs a high pixel count and a very good lens.

DSLR (digital SLR) cameras

After several months of research, I finally discovered that to get a result even approaching the resolution of a 6 x 4.5 cm transparency, I would need to spend £2,000–£3,000 on a professional digital SLR camera or get a professional photographer to make digital files for me, at about £20 per image; even then the results would often not be as crisp as shots using the old technology. Here it's worth mentioning that a medium-format digital camera, Hasselblad or Mamyia for example, will set you back over £12,000.

Marketing techniques try to persuade us to buy the latest thing and whilst digital cameras are great for holiday snaps, the results are still often below the standard of medium- and large-format traditional photography, and this includes some of the expensive DSLRs. The situation is changing somewhat, with the advent of so-called full-screen sensors. These are twice as large as sensors on earlier DSLR cameras, and are capable of capturing far more information. A high resolution file is not necessarily dependant on having

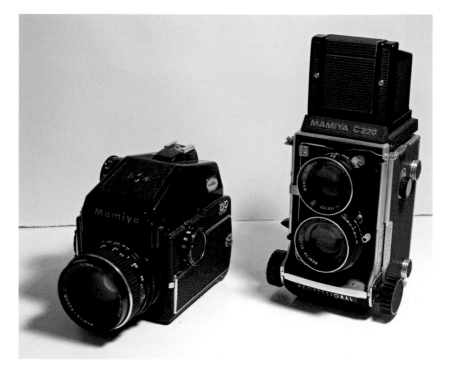

Mamiya cameras.

millions of pixels, but on the clarity of the recorded image: full screen sensors on cameras like Nikon D700 or D3 provide very sharp images using these sensors. Before investing a large amount of money, take good advice!

Cheaper digital cameras are very useful for taking photos at a lower resolution and making small files that can be sent as 'thumbnails' for an article or book. What is frustrating is that the big camera companies have had the technology to make affordable cameras that will take very high-resolution images for years, but will not produce them because of their marketing strategies.

Getty Images (a well-known picture library) has recently issued guidelines for photographers who supply them with photos, suggesting cameras that meet the minimum requirements of their archive, and these are mainly high-end Nikon and Canon models. If you are able to afford one of the latest generation of high-resolution digital SLR cameras, it will need a full-frame sensor and should preferably have a pixel count of between 12 and 20 million pixels.

The next hurdle is using a digital imaging program to work on the digital images produced by the camera, and for this you must have either Photoshop or another acceptable program often sold with the camera.

COMPUTER SOFTWARE

Produced by the US company Adobe, Photoshop has long been the market standard for editing digital images and is a very good program, but you will need time to learn how to use it properly. Cameras store digital information in various ways; publishers, printers and graphic studios demand certain formats, such as RAW or TIFF. The full version of Photoshop retails at around £2,000 but Photoshop Elements, which costs around £120, will enable you to produce acceptable digital files. Recently, I was asked to produce digital files for a new book and the graphic designer in charge of the layout and design asked me for NEF files, which is the name given by Nikon to the RAW format files produced using the in-house software sold with their high-end cameras. These have proved at least as good as files produced using Photoshop.

The relatively new RAW file format is rather similar to a negative in analogue photography, because the camera records the information in a format that has to be converted into a visible form by the computer. An 18mb RAW file will convert into a 50mb or 60mb TIFF, which is usually enough to satisfy the most exigent layout artist. However, before converting to a readable format or simply storing the RAW file, it is often necessary to adjust the colours and tones of the image. This is quite easy if the image is your own and you know its colour values well (in fact doing this reminds me of the time that I spent in the darkroom printing from negatives – it's actually quite fun and once you are happy with the image it can be stored as a RAW file for future use). If you are working for a publisher, ask the layout department to specify which file format they prefer.

As a general guide, for thumbnails, low-resolution shots to be sent as attachments via email, or for web sites a good format to use is a jpeg; a size between 75 and 300KB will be sufficient. To print a photograph, a jpeg file sized from 2.5MB to 6MB should produce good, sharp prints up to A4 size. For reproducing images in books, magazines and so on, the best choice is to save files as high resolution tiffs, which will probably be 50MB plus. Note that if you are working with a publisher, it is more than likely that they will specify the size and spec of any photos required, so it is best to ask them what they want before beginning.

PHOTOGRAPHING ARTWORK

Photographing paintings is not an easy job, but if you cannot afford the services of a professional photographer, here are some guidelines.

Camera

- Buy the best camera you can afford. Many publications will still accept transparencies. A good 6 x 6 cm (2¼ x 2¼ in.) or 6 x 4.5 cm (2¼ x 1¾ in.) traditional medium-format camera will cost between £200 and £500, depending on what make it is. Mamiya cameras are very good and the older twin-lens reflex cameras have no electronics to go wrong! Photography on 35 mm transparency film is too small for serious publication work.

- As mentioned previously, if you are using digital technology, you can only get top-quality results from a high-end camera. Most publications will not accept digital files of less than 50mb (see above).

- Never use a wide-angle lens (i.e. less than 50 mm for a DSLR or 80 mm for a 6 x 6 cm), as this will distort the shape of a painting. Generally, a 50 mm lens will do a very good job on a modern DSLR. Zoom lenses, though practical, are not as sharp.

- Always shoot with a tripod.

- Set the camera to the light conditions that prevail. Use flash only with matt artworks: anything with a shiny surface makes it impossible to get a good result with flash, even when using polarising filters. Many editors ask for bracketed files, i.e. a range of four to five shots of the same picture at different exposures – a good camera will do this for you.

Lighting

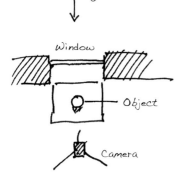

Natural light

Window

Object

Camera

- Works on paper are probably the easiest to photograph because there is very little glare from the material. I often use a flash for this job because it gives an even light over the whole surface of the paper unless it's a very large drawing or watercolour. Fix the artwork to a wall and make sure it is flat.

- *Using natural daylight* Daylight can produce very good results with an analogue camera. For many years I used Fuji daylight film and a medium-format camera, and shot in full sunlight, obtaining very bright, sharp results. I find sunlight less good for DSLR work, where shade is better. High-end Nikon and Canon digital cameras are better used out of direct sunlight, which tends to bleach out colours.

- *Using flash* All cameras are different, some have good built in flash others don't: the same flash used in two different rooms will give different results, which makes this an immensely complicated subject. Most photographers use some sort of flash synchronised to the camera – either a flash gun attached to the camera body or lamps and umbrellas. A few high end cameras have built in flash which can be very good, otherwise follow the camera and flash gun settings.

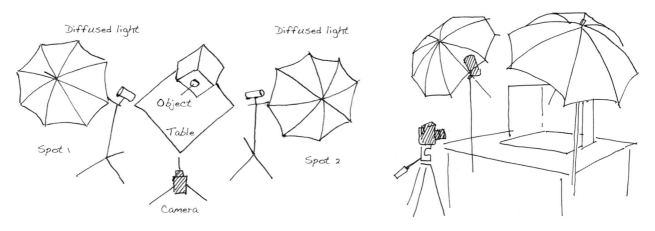

- *Incandescent* For analogue tungsten film, the lights need to be incandescent: these are hot, expensive and short-lived; more modern flash lamps are increasingly LEDs, which are cool and long-lasting. If you are using a DSLR, set the camera for the type of lighting used, i.e. daylight, shade, incandescent etc.

- *Diffused flash* Professional photographers use diffused light (i.e. non-directional) for nearly everything, and a typical set-up is shown above. The umbrellas have a silver matt finish inside and the lamps are directed at this and synchronised with the camera. This is a very practical solution for photographing objects in studios or photographing interiors.

- The most difficult works to photograph are oil or acrylic paintings, especially when they have been varnished, as the camera picks up glare off the surface. Direct flash is out of the question and even diffused light will quite often cause bright flares of light on the surface. A polarising filter is some help, but shuts out much light from the lens. The set-up shown below is probably the best option, but the lights often have to be moved around to get optimum results.

- *Shooting against the light* This is very good for atmospheric shots of objects, but the camera should be pointed down at objects lit from above by daylight. It is worth experimenting with daylight in the studio: for example, light reflected off white boards on to the objects to be photographed will give startling effects.

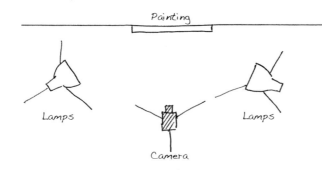

Storage

I use Flash memory cards with my DSLRs, but you can transfer digital images direct from the camera to the computer using a USB cable. Take care when storing your work (see pp.126–7).

RGB and CMYK

RGB – red, green, blue – are the colours used in a computer monitor. Cameras store information in RGB format. Printing processes output in CMYK – cyan, magenta, yellow, black (except for giclée requirements as below). Some printers prefer digital art files to be supplied in the RGB format with ICC profiles (colour management profiles) attached. The printer will then convert images to CMYK using colour management methods. This helps to preserve the best possible detail and vibrancy.

Giclée prints

If you are intending to have giclée prints made of an artwork (now often called pigment prints), which are fundamentally inkjet prints using archive-quality inks (actually pigment dyes), the printers will ask you for a 50mb, 16-bit RGB This is where things get complicated, but simply put, you can only get a 50-megabyte file using a high-end digital camera and either photographing to produce TIFF files or converting RAW files to the TIFF format on a computer. The more bits in an image, the more colour tones there are in the files. 'Uninterpolated' means that you should not make any changes to the image on the computer (don't resample to bilinear, bicubic etc.) because this can cause a loss of detail, or in a worse case scenario, for the file to corrupt. Photoshop or your camera's software will help you jump through these hoops!

Giclée prints are made on buffered stock paper (specially coated cotton rag paper for printing), usually Arches or Hahnemühle cotton rag, but canvas, plastic, metal and so on can also be used for this very versatile and interesting new technology.

STORING DIGITAL IMAGES

So now you have the camera and the computer software and your images are ready: how do you store them? The current method is to burn the images on to a CD-ROM, but here we come up against one of the most interesting questions in modern technology – how long does a burned CD last? Nobody seems to know, but the consensus suggests from 5–50 years.

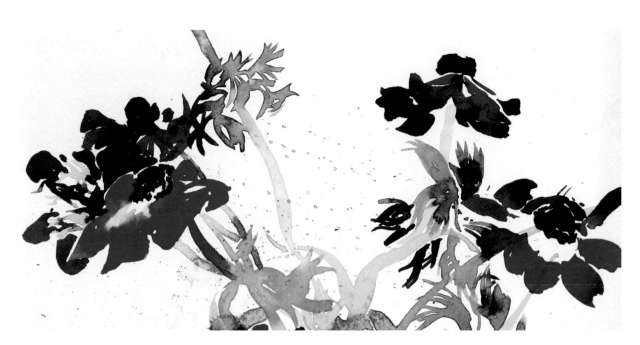

An external hard drive is a good compromise for storage, since most of the time it is turned off, reducing wear and tear, and is only used when images or other files are being loaded into it. Most of the photographers that I spoke to whilst researching this book told me that they use dedicated external hard drives for their images, keeping them separate from all the other files in the computer, and at the time of writing this seems to be a good solution.

Possibly the best method would be to store your valuable high-resolution images on a host site via the Internet: searching for 'online storage' will bring up a number of sites where you can rent vast amounts of safe storage space, but this will cost money and I feel uneasy about sending my images into cyberspace. The latest development in the ongoing business of archiving work is to store the high-resolution images on – guess what – film!

Red anemones, a giclée print on Hahnemuhle buffered cotton rag paper, 45 x 76 (17 x 30 in.). Giclée, or pigment, prints can be made in almost any dimensions provided that the scan is of high enough quality to produce the fine detail. Editions should consist of numbered prints all the same size.

14
DESIGNING A STUDIO

Few experiences are more agreeable for a painter than to work in a well-designed studio. I have had studios in a wide variety of places, often a converted bedroom or a hotel room while travelling, and quite often in the studio of a fellow artist – it's always interesting to see how others plan their space.

BASICS

Perhaps it's easier to define what is *not* desirable in a studio: south light that blinds you when the sun comes in; neon lights, which flatten relief and bleach colours; not enough light. Insufficient heating in winter, and noisy neighbours are also to be avoided.

White or off-white walls are usual, with possibly a curtain and a mirror for background effects. A floor of tiles, lino or vinyl is practical; wooden floors, although sometimes difficult to keep clean, are easier on the feet for those who spend long hours standing. A sink with running water and a good-sized drainer is fairly essential too, for preparing colours and washing brushes. It can be very expensive to heat a very large space, so unless you have plenty of money, keep the studio small if you live in a cold climate.

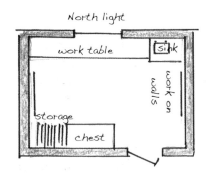

Spare room

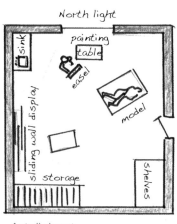

A studio layout

For portraits or nude studies, it is very useful to have a dais if there is room in the studio. These are usually about 30–40 cm (12–15¾ in.) high and roughly 2 m (6 ft 6¾ in.) square, and can be simply made using plywood (2 cm/¾ in. thick) on a strong wooden frame. For an artist working from a sitting position, a dais can give the subject an imposing aspect – looking down on a subject is often a difficult viewpoint – and by raising the subject slightly, a dais can suggest new compositional possibilities.

A corner of the author's studio.

LIGHT

You need as much natural light as you can get, and ideally this should be north light (or south light if you live in the southern hemisphere), which usually gives fairly constant light on both subject and support. If your studio is overlooked, it can be helpful to fit etched glass (which is opaque) to the windows.

For right-handed artists, the light should come from the left on to the board or canvas; for those who are left-handed, from the right. Top light is fine, too, but is better if diffused by opaque glass. I find that if the subject and support are both lit from the same source, it is a help.

Some painters like to adjust the amount of light falling on their work or subject using screens or moveable panels – in Georgio Morandi's studio in Bologna there were hinged panels that could be moved to allow the desired light on his still-life groups. Many painters like Venetian blinds, which can be adjusted to give the required fall of light.

In some of the great custom-built studios that can be seen in parts of London's Chelsea, the light source was often a great high, north-facing window and this gives a really marvellous light on almost anything – lucky the painter who can afford one of these! A well-known London painter has a studio with a large window from floor to ceiling, and using the light from this has made many successful *contre-jour* (against the light) compositions.

Artists who paint only from drawings or photographs and those who have limited space – working in a spare room, for example, should set up a work table under a north-facing window.

Artificial light

I also use artificial light on dull winter days or if I want high contrast, and I like best, a warmish light. If I am obliged to work with neon light, I warm it up with some spotlights or halogen lamps. It's a good idea to have one or two quite powerful lamps over the window so that failing daylight can be augmented from the same direction to enable work to continue. Warm or cool lights, neon lights, LED lights, halogen lights and so on are available in many different types. As a young man, I drew Quentin Crisp at evening classes in the old studios at St Albans Art School and the space was lit by a number of powerful incandescent lights, which provided light and warmth for the model.

STUDIO EASELS

Studio easels are essential for larger works on canvas or panel: they should be rigid and adjustable by height. Some of the more expensive ones are on wheels that can be locked when the easel is in the right position, and the height of the support bar can be changed using a handle. Many commercially available easels are of very poor quality – not heavy enough to be stable and difficult to adjust. The so-called radial easels found in many studios are a good compromise, since the better ones are made of heavy wood and can be adjusted with large wing nuts.

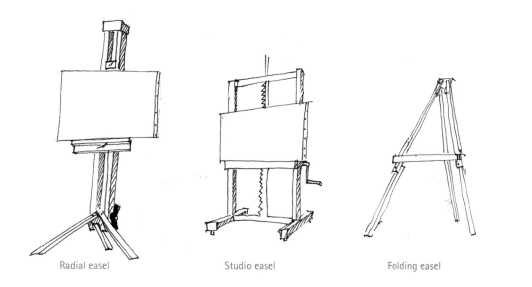

Radial easel Studio easel Folding easel

PAINTING TABLES

Painting tables are another essential and should be adjustable to suit the height of the painter – otherwise backache will result. I have an old architect's table in my studio, which can be set at almost any height according to my needs – for example working on an etching plate on a flat, low table would be very difficult: the plate should be near the eye while the etcher is in a comfortable upright stance; similarly, a slight incline on a watercolour can help the successful completion of large washes. Under the table, it's useful to have shelves for storing boards, paper or frames, and a shelf unit on wheels, which can be kept under the table and pulled out when required is a great addition to a studio.

A smaller table or cupboard unit with a marble or glass top is very good for using when painting in oils or acrylics, as it can be placed beside the easel and the top used as a palette while all the paints, thinners and solvents are kept below in the cupboard. Here again, it's a good idea to have castors on two legs of the unit so that it can be moved about easily.

A drawing table.

A plan chest.

Studio objects.

STORAGE

If you have room, it's a good idea to have a plan chest for storing papers and finished work. Keep cupboards and shelving away from the main work area so that they don't prevent free movement around the easel and subject.

Racks for canvases, boards and frames can be easily made from either plywood panels or timber uprights. They are sometimes incorporated into a storage cupboard or have doors to keep out dust and dirt. Place in a corner away from the main work area.

INSPIRATION

Collections of objects in a studio can be an inspiration, providing the material for a still life on a rainy day or acting as a background to a composition, but for me they are the repository of memories, bringing to mind times or events past. Well-known painters very often use the same objects over and over again – Giorgio Morandi is one who comes to mind; Ben Nicholson another.

Project

- Measure carefully the space intended to be your studio and do make a ground plan to scale. On this, work out possible light sources and how the studio can be arranged to make best use of the light available.

Still life objects.

BELOW: *Solstice*, pastel and collage, 37 x 57 cm (14½ x 22½ in.).

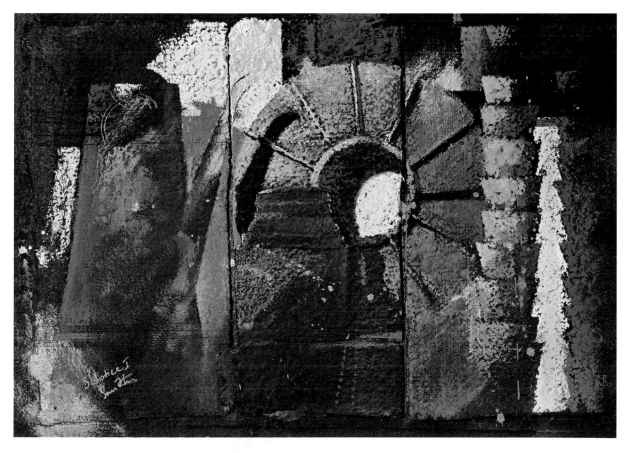

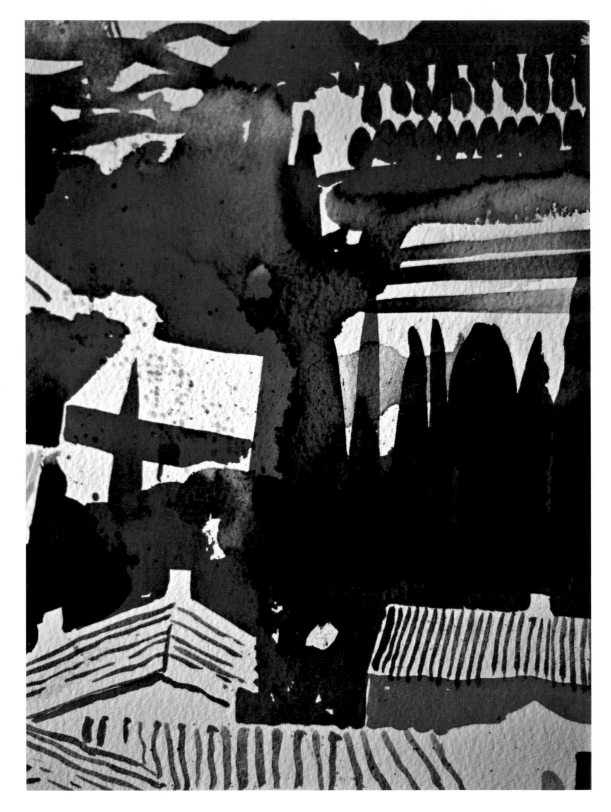

APPENDICES

RECOMMENDED PAINT MANUFACTURERS

See also p.24 and pp.29–37.

The following is a fairly subjective list: it is nearly impossible to test the many hundreds of different paints available on the market. Important points to bear in mind are pigment content, binders and transparency/opacity.

Pigment content

Generally, the more pigment ground into a paint, the stronger the colour, although some pigments – such as phthalocyanine colours – need a considerable amount of extender as the unadulterated pigment is so strong. Paints branded as students' quality will give weaker tints, contain extenders and often use poorer-quality pigments, i.e. cadmium yellow hue (probably a mix of less than permanent pigments) rather than the more expensive cadmium yellow. At the time of writing, Jackson's oil paints have a high pigment content for the price paid compared to some other producers.

Binders

Watercolours often contain too much glycerine; oil paints an excess of oil. Some paint-makers specify the type of oil used in grinding the paints. Good oil paints should be pleasant to use, have a 'buttery' feel and possess clear colours. Watercolours should be pure with no gum or binder visible and easy to dilute.

Transparency

Certain colours, such as ultramarine and all quinacridones, are naturally transparent as watercolours, fewer as oils. If you find that such colours are not transparent, they almost certainly contain extenders like chalk.

FACING PAGE: *Over the Blue*, giclée print, 76 x 56 cm (30 x 20 in.).

Manufacturers

Many of the firms listed supply art accessories for many different media and disciplines, as well as colours.

Blockx Belgian firm making some really good oils and watercolours. Their earth colours for watercolour, however, are not my favourites. Very good bright reds, yellows, blues and some greens. Expensive.

Daler Rowney Their extensive catalogue contains useful information on several techniques as well as good, clear photos of products. Everything that an artist needs is available. However, whilst the catalogue contains details of pigments used, I was disappointed to find that certain of the Artists' oil colours use pigments that are not the best available like Rowney red PR9, Napthol red rated as II-III ASTM. It is reassuring to see that they still produce a flake (lead) white – lead white is irreplaceable for painting flesh tones.

Dick Blick A big supplier of art materials in the USA and painters can buy almost everything they need there. It's a pity that their own brand of studio oils uses some old-fashioned impermanent paints, they do however print the CI name code on the tube, but reliable colours are available from other major brands at competitive prices and some of their products are first class.

Gamblin Specialising in fine colours, this is one of the very best US producers of artists' oil paints, mediums and varnishes and, while not cheap, they can compare with some of the very best colours available today. I am still puzzled to find hansa yellow (PY74), not entirely lightfast, offered by this firm.

Golden Artist Colors Acrylic products: fine, strong colours for painters and a good range of pastes and varnishes for the specialist. This US company is present worldwide.

Guardi Good pigments, competitively priced; also some useful medium-priced paints. A large range of products at good prices. Products available from Great Art and Boesner.

Jackson's Surprisingly good colours considering their reasonable prices. I particularly like their primary colours in oil, and the quality of the bigger tubes of watercolour. When buying reds, avoid alizarin crimson (PR83). This unreliable pigment is still offered by many firms. Jackson's produces a comprehensive catalogue of all sorts of products for the artist.

Kremer Pigmente A German firm that produces superlative pigments for painting. I've long used their pigments for making oils, watercolours and pastels; they also do some antique colours for restoration. Rather expensive.

Lefranc & Bourgeois Fine French colours. I use these with pleasure and even the cheaper large oil tubes are good for earth colours. Also available: good watercolours and acrylics, and a range of products for other media.

Liquitex For many years known for the quality of their products and used as a reference for acrylic colours; in recent years there have been questions about pigment permanence. Check the pigments used.

Lukas Popular German company producing a range of paints for all media. I particularly like their Studio oil paints but am less keen on the watercolour range. Recent testing of a titanium white oil paint showed a higher pigment content than any other similarly priced paint. A small range of accessories is available.

Maimeri Italian colour-makers. The Venezia watercolours I tried were full of glycerine and had very weak pigments, but the Blu series of watercolours is excellent. I've enjoyed their earth colours for landscape painting. Maimeri offers a range of art products as well as paints.

Michael Harding His range of artists' oil colours was used by the English colourist Howard Hodgkin, amongst many other serious painters. These are pigment-rich, excellently made colours, which are fairly expensive. Harding tells us what's in the tube, too. Makes some rare colours, such as lapis lazuli.

Old Holland Very good Dutch colours. Check the lightfastness of some pigments.

C. Roberson Famous old firm making artist's quality paints and products; expensive.

Royal Talens Dutch company making colours for all media. Generally good, although I'm worried about their use of fugitive azo reds in the economy colours: there are better, similarly priced pigments than this.

Schmincke Well-established German company producing a big range of products for all media. Generally pretty good, but ask to see the catalogue to check the pigments used. Available: oil colours, watercolours, pastels, inks etc. I find their earth colours, both as watercolours and oils, very poor.

Winsor & Newton Good colours in oil, watercolour and acrylic. A comprehensive catalogue of products for all media. This old and trusted British company has been supplying artists with reliable colours for over a century. They have kept up to date with new pigments and products.

I'm sorry that I can't include some of the smaller, very good producers of paints: they are often as good or better that the big firms listed above. Before you buy paints, check the binders and pigments used.

PRICE COMPARISON

I thought that it would be of interest to show a list of comparative prices for the same oil colour, cadmium lemon yellow, and in roughly the same quantity (38–40 ml). Prices were correct at the time of publication and do not include post and packing. As can be seen, there is a fairly large price range here, but generally the more you pay for paints, the higher the pigment content. It's also worth looking around for the best price.

Blockx £19.85 US$68.68

Daler-Rowney £9.75 US$6.25

Gamblin £16.95 US$23.95

Jackson's £5.45 (For cadmium yellow light.)

Lefranc & Bourgeois £12.99 US$17.95

Michael Harding £17.00 US$34.58

Old Holland £19.68 US$54.49

Royal Talens: Rembrandt range £11.05 US$27.75

Schmincke: Mussini range £19.91 US$25.15

Winsor & Newton £11.45 US$35.25

SUPPLIERS

For pigments and materials for all media, try the following suppliers.

UK

Atlantis (www.atlantisart.co.uk)
A great store in central London supplying a huge amount of good material.

Brodie & Middleton (www.brodies.net/)
Good, well-established firm selling very competitively priced pigments and products for stage painting etc.

L. Cornelissen (www.cornelissen.com)
A very old London firm still supplying very good products, especially pigments.

GreatArt (www.greatart.co.uk)
Parent company is Gerstaecker, a German company. Competitive prices and a good range of products. Gerstaecker and Boesner are both German giants of art supplies.

Jackson's (www.jacksonsart.co.uk)
Extremely competitive supplier providing colours, brushes and a huge range of excellent products at unbeatable prices. The prices of colours and brushes are particularly interesting.

T. N. Lawrence (www.lawrence.co.uk)
Well known for their printmaking materials, they also offer an interesting and full range of art supplies. Competitive prices for watercolour papers.

Spectrum (www.spectrumoil.com)
Spectrum produce fine studio paints for oil and acrylic and have a very professional approach to pigments and binders. Competitive prices, too.

USA

Dick Blick (www.dickblick.com)
One of the best-known US suppliers. A big range of some of the best artists' materials at competitive prices and a good online service. As well as their own range of studio colours, they also offer products from some of the best fine art ranges – Gamblin oil colours, for example. Very good brushes and canvases.

Jerry's Artarama (www.jerrysartarama.com)
Another online store with a large selection.

Australia

Art Spectrum (www.artspectrum.com.au)
Fine Australian colours.

Discount Art Warehouse (www.discountart.com.au)
A good selection of products for artists and students.

GLOSSARY

acrylic Chemically produced paints, binders, glues and varnishes with great elasticity. Water-soluble.

alkyd resins Chemically produced oil-based varnishes and oils for painting. Transparent, fast-drying and non-yellowing.

alla prima Term used to describe the technique of making a painting in one sitting without underpainting or glazing.

American Society for Testing Materials (ASTM) The ASTM reliably rates pigments for lightfastness from I (very good) to IV (very poor). They will also provide information about the methods they have used for testing.

aqueous dispersing paints Procion dyes were first produced by ICI in Britain and were intended for textile dying. They are extremely intense colours, which can be used to work directly onto cotton, linen, paper etc.

azo Also called monoazo. A very large family of pigments, some of which are good as artists' colours. Hansa yellow, which describes a big range of yellows, is good; PY73 is permanent ASTM I. Azo reds are generally impermanent although PR112, Napthol, is rated ASTM I.

binding media Drying resins, glues and other products that are used to hold pigments and extenders in suspension, i.e. usable as paint, or for sealing wood, canvas and other supports.

body colour White or pale opaque paint used in wash drawings, watercolour and gouache to add depth or highlight. Known as *blanc de ceruse* in French.

calcined The process of heating up pigments to darken them.

casein glue A binder obtained from milk and used in the same way as egg emulsion in tempera painting.

Chinese white Name given to zinc white prepared as a watercolour.

cockling Wrinkles and stretching in damp paper.

collage French word meaning to stick or glue. In painting, the word is applied to various materials glued to boards or canvas and sometimes painted over.

Colour Index (CI) The index of pigments used for all types of paints. The essential reference for artists wishing to use permanent, safe colours.

Conté à Paris A well-known French maker of artists' materials, which manufactures conté sticks, the best-known hard pastel colour sticks.

contre-jour French term meaning against the light. The English painter J. M. W. Turner used this device again and again in his landscape compositions.

cradled panel Panel of wood to be painted and held rigid by a frame attached to the back of the panel. See illustration on p.87.

dammar resin Produced from the resin of Asian trees, dammar crystals look like dusty, pale yellow sweets. When these are dissolved in turpentine they produce a fine, clear, quick-drying and non-yellowing varnish for paint mediums and finishing.

deckle Name of the mould or frame used for forming sheets of handmade paper. By extension, the name of the ragged edge that is a characteristic of handmade paper.

distemper From the Latin 'to mix', distemper is

an outdated word, usually referring to glue and pigment mixed with water to produce a pale paint or wash. Whitewash is a distemper made using lime and chalk, used to paint walls.

drying agents Also known as siccatives, these are products that speed the drying of oil paints. Useful with some very slow-drying paints, but can cause cracks in the paint film.

DSLR Digital single-lens reflex camera.

dyes Simply put, a dye is soluble in water and a pigment is not. Some of the so-called lake pigments, usually fugitive and rarely used nowadays, were produced by mixing a salt with dye to produce a powder which could be ground with a binder.

emulsion Amalgamation of two or more liquids made by a variety of mixing techniques.

expressionism Name given to early 20th-century German painting much influenced by Vincent Van Gogh.

extenders Additives to paints – either to bulk out cheap products, to increase opacity, to improve handling characteristics or to improve overpowering colours such as Prussian blue or phthalocyanine blues and greens. Commonly alumina hydrate or blanc fixe, fine chalk.

fat over lean Traditional oil painting begins with thin paint layers and often but not always thicker paint, often highlights, are added last. This is called painting fat over lean and it is still the yardstick for oil, acrylic, pastel and gouache.

fugitive Not permanent; usually applied to pigments that fade with time.

gesso An Italian word for a hard plaster used as a base for gilding and painting.

giclée print *See* pigment print.

glaze Thin layer of transparent colour applied over previous dry layers to enrich them.

granulation Usually refers to pigments in watercolour which separate into particles on drying.

graphite Carbon deposits of the same family as coal. Mineral graphite is also called, incorrectly, lead in pencils.

ground Finish applied to boards and canvases immediately before beginning painting.

grounding The process of laying a protective paint or ground on a support.

gum arabic Water-soluble acacia gum used as a binder and medium for pigments in watercolour and gouache paints.

hard-sized Usually used to describe paper that has a smooth, impermeable surface due to a coat of size, a type of glue. Paper with no size is sometimes called waterleaf; weak or slack sized paper has medium size.

hue Refers to the saturation of pigment strength. Also, on the colour wheel, a pure colour such as red or blue.

impasto Heavy paint layers or a thick paste, often coloured, applied to supports (sometimes with a palette knife) for effects of texture and surface.

imprimatura Flat colour applied to a support in preparation for painting. Usually a thin coat of tempera or an acrylic earth colour. Often, the composition is established on this before painting begins.

Ingres paper A fine laid paper for drawing, named after the great French painter J. D. Ingres.

laid paper Paper produced from a deckle constructed of very fine parallel lines, the pattern of which is transferred to the paper.

lake pigment Precipitated dyes with inert binders. The old lake paints were very unreliable but modern ones can be better – M. Harding for example makes some permanent lake oil colours.

lapis lazuli Semi-precious stone which, when ground with a binder, makes a beautiful blue paint. Very expensive and quite difficult to grind.

LED lights Light Emitting Diode. These are long-lasting lights that generate no heat.

lightfastness or permanence In a pigment, the quality of being able to resist fading in strong light over many years.

linen Fine woven cloth made from the fibres of

the flax plant. Linen rag paper was the preferred material of the great 19th-century water-colourists. Not to be confused with cotton rag.

linseed oil Pressed from the seeds of the flax plant, this fast-drying oil is the most common binder for oil paints.

linters Cotton or linen prepared for making paper is pulped until it breaks down into linters, or small threads.

marouflage A French word meaning to glue canvas or paper that is to be painted to a support – usually a wall, panel or a canvas. Canvas was often glued to walls using lead white and oil, but these days marouflage is more often done with acrylic glues.

Mass tone The colour as it appears without the ground or another colour underneath it showing through. Usually applied to opaque colours.

medium A material or form/technique used by an artist, such as watercolour, acrylics, oils etc. Also used to describe diluents for painting.

medium-format photography System used to produce 6 x 6 cm (2¼ in.) square colour transparencies, used universally until recently for good-quality reproductions. Now largely replaced by digital file formats.

muller Heavy glass hand-held implement with a flat bottom used for grinding oil paint.

museum board The best acid-free mount board for watercolours and drawings.

museum glass In conservation and for valuable paintings under glass, museum glass is used – it blocks ultraviolet light, which damages papers and colours, and reduces reflections.

neutral colours Often greys, browns or dull greens, which are used to bring brighter colours to life or to calm the atmosphere of a painting.

neutral pH Chemical definition of a substance that has a pH of 7: neither acid nor alkaline.

opacity The opposite of transparency in colours.

overpainting Painting over previous dry work

ox gall A dispersing or wetting agent used sometimes in watercolours to increase flow of paint on paper.

painting medium Oils, resins and fluids used to dilute colours to make them easier to handle in paintings.

palette Name used for the choice of colours habitually used by a painter. Also the usually wooden tray that is used to arrange colours for painting.

paper format For convenience, the term 'portrait format' format refers to paper higher than it is broad, and 'landscape format' to paper that is broader than it is high.

pH Measure of acidity or alkalinity of water. Solutions with a pH greater than 7 are alkaline; with less than 7 acid.

pigment print Contemporary term for high-resolution inkjet print, also known as a giclée print. The inks used are now archive-quality, i.e. the pigments are lightfast.

polymer Group of chemical compounds, glues and varnishes used in acrylic painting.

portfolio Old term for cardboard folder used for transporting artworks.

primer Glues and paints used to protect canvas, boards or other supports prior to the application of a ground.

PVA (polyvinyl acetate) A ubiquitous product the world over, sold in the form of white wood glue or 'binder'. This basic polymer glue can be used to make simple acrylic 'distemper', seal wood or canvas, or glue paper or wood together.

quinacridone Permanet, transparent modern pigments, mostly reds on the blue side of the colour wheel.

rabbit-skin glue Glue made from the hides and bones of animals, sometimes rabbits.

Rapidograph Originally a German drafting pen for architects; a fine pen of various nib widths containing Indian ink.

RAW files File format enabling high-resolution images to be stored using less computer memory than older formats.

retarder Liquid used in oils and acrylics to slow the drying of paints.

reticulation Fine lines and cracks seen on the surface of paintings and usually caused by layers on the paint surface drying at different speeds.

sailcloth Heavy bleached cotton used for painting. Also called cotton duck.

salt Common salt, in powder or crystal form, is sometimes used in watercolour painting to create granular effects.

sanguine Literally 'bloody'. Red chalks for drawing.

shade (colour) The result of mixing black with a pure colour, i.e. shades of blue.

siccative *See* drying agents.

size Another name for the glues used in preparing papers and canvases to make them smoother and less absorbent (*see* hard-sized).

skin glue Plaques or granules of animal skin, usually rabbit, which, when warmed in water, dissolve to make an impermeable, transparent and flexible primer. Also used in the preparation of grounds.

stretcher In painting, the wooden frame on to which canvas is stretched prior to painting. The best stretchers have wedges in each corner to tighten the canvas and are often braced.

TIFF File format commonly used in digital imaging techniques. Publishers usually require a 50mb TIFF file for colour reproductions.

tinting Adding white to a pure colour to obtain tints.

tinting strength High pigment content gives paints with high tinting strength

toned papers Coloured papers used for pastels and chalk drawings.

toxicity The degree of harmful material in a product, such as lead or carcinogens in a paint. Flake white, for example, has a high toxicity.

transparency Paints with a low covering power, through which grounds or previous paint layers can still be seen.

turpentine Liquid solvent for oil paints made by distilling pine resins.

underpainting *See also imprimatura*. First composition painted over the ground, nearly always with thin paint.

Venice turpentine Sticky gum additive to paint glazes made by distilling larch resin.

washing out A term used in watercolour and acrylic techniques to describe the action of lifting previous paint layers, either by washing or scrubbing.

watermark A name or maker's mark is sometimes incorporated into the deckle or mould when papermaking, which can be seen by holding the finished paper up against the light.

wedges Slivers of wood, usually beech inserted into slots at the corners of stretchers. They are knocked into the slots provided to tighten the canvas.

wet-into-wet Painting wet in watercolour.

wetting agent In watercolour ox gall, makes certain pigments and paints easier to mix or disperse in water.

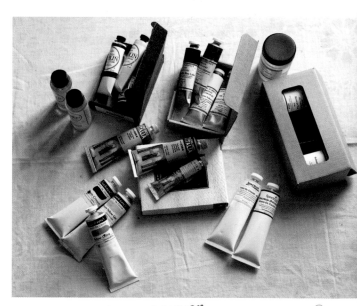

GLOSSARY

INDEX